RETRO GAMING

A BYTE-SIZED HISTORY OF VIDEO GAMES

RETRO GAMING

A BYTE-SIZED HISTORY OF VIDEO GAMES

Mike Diver

This paperback edition first published in 2022
First published in Great Britain in 2019 by LOM Art,
an imprint of Michael O'Mara Books Limited
9 Lion Yard
Tremadoc Road
London SW4 7NQ

A CIP catalogue record for this book is available from the British Library.
Papers used by Michael O'Mara Books Limited are natural, recyclable
products made from wood grown in sustainable forests. The manufacturing
processes conform to the environmental regulations of the country of origin.

ISBN: 978-1-912785-86-5 in paperback print format
ISBN: 978-1-912785-11-7 in e-book format

1 2 3 4 5 6 7 8 9 10

www.mombooks.com

Cover design by Siâron Hughes
Designed and typeset by Darren Jordan

Cover illustrations from shutterstock.com

Every reasonable effort has been made to acknowledge all copyright holders.
Any errors or omissions that may have occurred are inadvertent, and anyone
with any copyright queries is invited to write to the publisher, so that full
acknowledgement may be included in subsequent editions of the work.

Printed and bound in China

CONTENTS

INTRODUCTION

Thanks for picking up *Retro Gaming: A Byte-sized History of Video Games*. I hope you find a fond memory or more tucked within its pages (and that you enjoy a pun). I know I've had a great time revisiting the games of my childhood while writing it.

Naturally, it's been impossible to feature everything; there's hardware, games and characters that have inevitably been missed. These pages you're holding represent a finite resource that can only be filled so far. Nevertheless, the games, and the consoles and computers we played them on, included in this book tell a complete and compelling story – of a world evolving from expensive, individual arcade machines to compact and affordable electronic playthings that have, in the decades since *Pong*, invaded the homes of countless millions. It's been 50 years since home gaming really began with the Magnavox Odyssey console in 1972, and still we're moving forever forward.

Cheers again for reading and reminiscing with me.

1 ATARI

PONG

One of the most important video games of all time began as a training exercise. Having founded Atari in the summer of 1972, Nolan Bushnell and Ted Dabney – who'd worked together on 1971's *Computer Space*, the world's first commercial arcade game – knew they needed another hit. It wasn't just their reputations on the line now, but that of their new company. And *Pong* absolutely delivered.

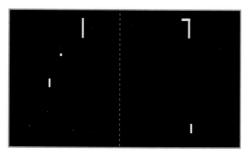

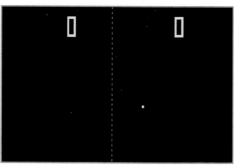

Allan Alcorn joined Atari as its first significant hire, and to get himself up to speed, Bushnell tasked the engineer – who had no games experience – with creating an electronic tennis game. That game was *Pong*, a basic bat-and-ball affair that didn't look like much but played smoothly and satisfyingly.

Pong possessed great accessibility due to its real-sport inspiration – everyone knows that returning the ball is good, and missing it isn't. Its instructions were wonderfully simple – 'avoid missing ball for high score' – and with just a single knob necessary to move each paddle, people

could play one-handed, keeping hold of their drink. Bar patrons were soon pumping change into *Pong* machines around the world.

Pong proved to be a true social game. Before its release, arcade units in the US were making an average of $10 per day. Pong quadrupled that, providing its makers with funds to further develop their arcade operations and, eventually, to move into home console gaming with the Atari 2600.

Famously, the first prototype *Pong* unit Atari installed was reported faulty by the proprietors of Andy Capp's Tavern in Sunnyvale, California. Alcorn discovered the problem was that the machine was overflowing with quarters, and had jammed; *Pong* was almost too successful for its own good. Without it, who knows what direction video gaming would have taken.

ATARI 2600

Atari wasn't the first company to release a console using swappable game cartridges – that was 1976's Fairchild Channel F with its 'Videocarts'. But the California-based company *was* the runaway winner of video gaming's earliest console wars, eclipsing its competitors.

Launched in 1977, the Atari 2600 dominated what's now known as the second generation of computer and video games. Initially sold as the VCS (Video Computer System), the 2600 was the biggest console on the market before the 8-bit era, and was only officially discontinued in 1992.

A platform for both Atari's games and titles from elsewhere – including famous Nintendo franchises like *Mario Bros.* and *Donkey Kong* – the 2600 sold around 30 million units in its lifetime, putting it well ahead of its peers.

Speaking to *Retro Gamer* magazine in 2018, Atari co-founder Bushnell said the 2600 'heavily exceeded my expectations ... We thought we would get up to 20 cartridges at most, and I felt the machine would have a three-year

life.' It would actually boast over 560 games, and sell for fifteen years across its various models.

The faux wood-fronted launch model – aka the 'Heavy Sixer', as a nod to the six switches on the console, which controlled the power, game difficulty and more – was succeeded by a number of iterations. Among these, an all-black, four-switch model, known as the 'Darth Vader' (see previous page), was released in 1982, and the budget-priced 2600 Jr (below), with a silver panel and rainbow stripe, followed in 1986.

The 2600 survived the worldwide video games crash of 1983, but only just. The recession that hit the industry, wiping out some $100 million in revenue, was down to several factors, including increased home computer sales and inferior software. Sales of 2600 cartridges fell heavily, and Atari ended up burying excess stock – around 700,000 units – as landfill.

The Nintendo Entertainment System (NES) would reinvigorate console gaming in 1985, but the 2600's legacy was already assured: in the late 1970s and early 1980s, to play video games was to play Atari games – the activities were one and the same.

In 2011, the 2600 was named by IGN as the second-best console of all time (after the NES). It was how millions first played *Pac-Man*, *Space Invaders* and countless other influential titles. As the entry point for the entire gaming medium, the 2600 will always remain special.

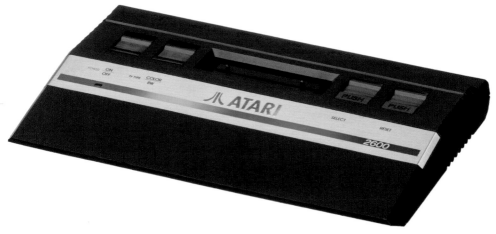

THE CRASH OF '83

Also known as the 'Atari Shock', the global video games crash of 1983 saw almost 97 per cent of console market revenue dry up, sending a sector worth over $3 billion spiralling down to a value of just $100 million by 1985 (before the launch of the NES). Saturation of the market was one factor in the crash, as Atari and its competitors accumulated large games libraries at the expense of quality experiences, and many of the new titles failed to attract the size of audience necessary to make them profitable.

In addition, console makers had increased production, thinking video games were a massive growth market. But while they were enthusiastic about this emerging medium, consumers simply weren't buying new hardware in numbers enough to match the manufacturers' output. Home computers, like the Commodore 64, were also becoming more affordable, offering a lot more than video games to buyers: they could run business applications and financial packages too, whereas consoles could only deliver the fun stuff, and therefore appeared to represent less value for money.

Several other circumstances conspired to create a perfect storm for the console business. It wouldn't be until the late 1980s and early 1990s that games-exclusive systems were booming again.

PAC-MAN

A pizza with a slice removed, or perhaps a hockey puck with a wedge cut out (hence his name 'Puck Man' in Japan) – however you see Pac-Man, there's no doubt that Namco's first game starring the character, released into arcades in May 1980, was a revelation.

Designed by Toru Iwatani, *Pac-Man* places its titular yellow hero in a maze, the objective being to consume all of the 'Pac-Dots' within it while avoiding four ghosts – Pinky, Blinky,

Inky and Clyde. For extra points, Pac-Man can eat fruit or special 'Power Pellets', which briefly allow him to eat the ghosts. Each stage is completed when all the pills are cleared and a new maze appears. Iwatani designed the game to have no ending, but a bug causes the right side of the screen to corrupt on level 256, rendering it unbeatable.

After a slow start in Japanese arcades, *Pac-Man* grossed more than $1 billion in North America in a year, making it bigger than *Star Wars* had been in cinemas. But it was the Atari 2600 port, released in 1982, that made it a household name. It sold over 7 million copies and remains the console's top-selling game of all time. But Atari overestimated its appeal,

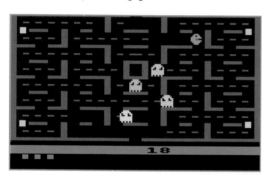

manufacturing about 12 million cartridges, thousands of which were eventually dumped into landfill.

COIN-OP CLASSICS COME HOME

The Atari 2600 was responsible for introducing both *Pong* and *Pac-Man* to home gamers, with the former appearing in 1977's *Video Olympics* compilation. And where there was *Pac-Man* – a game not developed by Atari, but licensed for the 2600 – there were several more coin-op hits from famous studios shrunk down to cartridge size.

Taito's *Space Invaders* might be the most important of these to land on the 2600. It was the first licensed arcade port in history, and the first home conversion to sell over 1 million copies. The game's popularity saw Atari console sales quadruple on its 1980 home debut.

From Nintendo came both *Donkey Kong* – released in arcades in 1981

and for the 2600 a year later – and 1983's *Mario Bros.*, which suffered somewhat from being released in the year of the global industry crash.

A host of familiar names from the arcades – Namco's *Galaxian*, Konami's *Frogger*, Gottlieb's *Q*bert* and Irem's *Kung-Fu Master*, to name but four – were ported to the 2600. These third-party titles, alongside Atari's own arcade conversions, gave the console a library to envy.

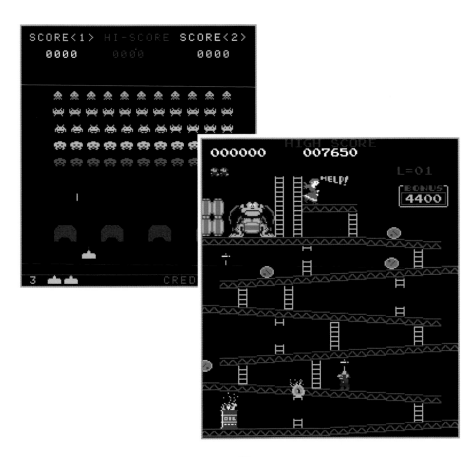

ASTEROIDS AND MISSILE COMMAND

Of Atari's own arcade smashes, few were as important to the company, and the success of the 2600, as *Asteroids* and *Missile Command*.

Inspired by 1971's decidedly primitive but massively important sci-fi combat game *Computer Space*, which pitched the player into battle against two enemy spaceships, the rock-blasting *Asteroids* was a major hit in arcades in 1979: Atari produced a whopping 70,000 units. The game came to the 2600 two years later, and was virtually identical to its arcade predecessor.

Missile Command released after *Asteroids* in the arcade, in 1980, but arrived first on the 2600, albeit by a matter of months. Despite its 2600 instruction manual describing a sci-fi setting, *Missile Command* was clearly inspired by the Cold War stand-off between the Soviet Union and the West, as the player has to intercept incoming enemy projectiles with their own rockets, protecting their cities in the process.

PITFALL!

The bestselling game on the 2600 after *Pac-Man* wasn't an arcade conversion, or developed by Atari. The David Crane-designed *Pitfall!* was produced by Activision, a company founded in 1979 by ex-Atari employees, and made exclusively for the 2600, before being ported elsewhere.

Released in 1982, *Pitfall!* moved away from the

single-screen platform of *Donkey Kong* to introduce the side-scrolling style we'd see in *Super Mario Bros.* and its ilk. The twenty-minute time limit encourages the player to perfect treasure-hunting runs through a jungle, and the game's protagonist, Pitfall Harry, became a de facto mascot for the 2600. He even starred in a tie-in cartoon.

E.T. THE EXTRA TERRESTRIAL

While *Pitfall!* and *Pac-Man* enjoyed critical acclaim, the eighth bestselling 2600 game really, really didn't. Indeed, 1982's *E.T. the Extra Terrestrial*, a spin-off of Steven Spielberg's blockbuster, is regarded as one of the worst video games of all time, with retrospective reviews calling it inane, with dull visuals and a disappointing story.

But in reality, *E.T.* isn't a total disaster. The player guides E.T. to find three parts of a telephone, in order to 'phone home' – a very streamlined take on the film's plot. It is let down by repetitive gameplay, sure, but it was Atari's own expectations that forged the game's legacy rather than its critical reception.

Atari produced 5 million cartridges but sold only 30 per cent of them – a

massive loss. The company had paid a lot for the *E.T.* licence, and the game's woeful performance would be cited as a big contributing factor to the 1983 industry crash.

STAR WARS: THE EMPIRE STRIKES BACK

Released in the same year as *E.T.*, this movie licensee couldn't have been more different to its homesick alien-starring counterpart. A speedy, side-scrolling shooter, casting the player as Luke Skywalker battling AT-AT walkers on the planet Hoth, *Empire* was fairly well received, and sold a million copies on the 2600.

While not an absolute essential of the 2600 library, *Empire* warrants a spotlight as the first *Star Wars* video game ever made. It was developed by Parker Brothers – a company better known for its board games, including

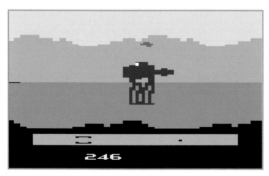

Monopoly and *Risk* – and since its debut, an almost unfathomable number of *Star Wars* tie-ins have been developed.

THE 2600'S SUCCESSORS

While the Atari 2600 enjoyed a long life, neither of the company's two follow-up consoles outlasted the older, more loved original.

First, in 1979, came the Atari family of 8-bit home computers, initially spearheaded by the 400 (aimed at younger users) and 800 models, featuring keyboards and cartridge slots. While these systems found an

audience, they were ultimately outpaced
by the likes of the Commodore 64,
and Atari completely stopped its
8-bit family support in 1992
after combined range
sales of around
4 million.
 But in terms
of pure gaming
machines, Atari's big
move was the 5200 (above). Released in 1982, the Atari 5200 used a lot of
the same technology as the 8-bit computers, giving it greater graphical
power. A lack of backwards compatibility with 2600 games at launch saw
Atari's audience hesitate (an adapter would follow, but too late), and the
console sold only a million units before being taken off the market in 1984.

 Learning from that mistake, in 1986 Atari released the 7800 (below),
which played most games in the 2600 library, so owners could hang on to
their favourites. However, fewer than 100 titles were developed to harness
the system's increased processing power.

 The 7800 co-existed with both the 2600 and Atari's XEGS computer-
console hybrid, and also competed against the Nintendo Entertainment
System and SEGA's Master System. Despite selling fewer units than SEGA's
and Nintendo's 8-bit consoles, the 7800 was profitable for Atari – and
the company would make a massive leap after its 1992 discontinuation,
launching the world's first 64-bit console, the Jaguar, in 1993.

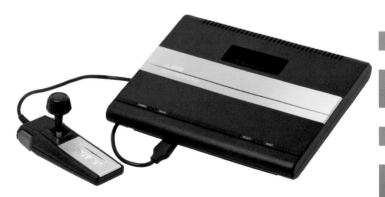

ATARI'S COMPETITION

FAIRCHILD VES / CHANNEL F
Maker: Fairchild Semiconductor
Launched: 1976
Discontinued: 1983
Sales: 250,000

BALLY ASTROCADE
Maker: Bally Manufacturing
Launched: 1978
Discontinued: 1985
Sales: unknown

PHILIPS VIDEOPAC G7000 / MAGNAVOX ODYSSEY[2]
Maker: Philips / Magnavox
Launched: 1978
Discontinued: 1984
Sales: 2 million

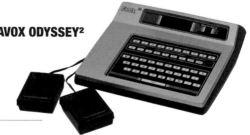

INTELLIVISION
Maker: Mattel Electronics
Launched: 1980
Discontinued: 1990
Sales: over 3 million

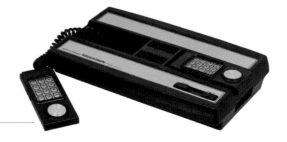

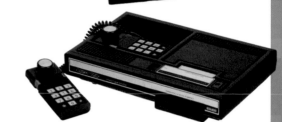

VECTREX
Maker: General Consumer Electric / Milton Bradley
Launched: 1982
Discontinued: 1984
Sales: unknown

COLECOVISION
Maker: Coleco Industries
Launched: 1982
Discontinued: 1985
Sales: over 2 million

THE ATARI 2600 TOP TEN

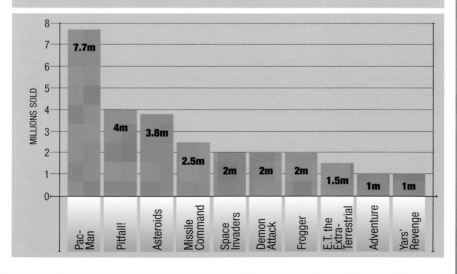

MILLIONS SOLD

Game	Millions Sold
Pac-Man	7.7m
Pitfall!	4m
Asteroids	3.8m
Missile Command	2.5m
Space Invaders	2m
Demon Attack	2m
Frogger	2m
E.T. the Extra-Terrestrial	1.5m
Adventure	1m
Yars' Revenge	1m

2 SPECTRUM VS COMMODORE

ZX SPECTRUM

Before SEGA and Nintendo split playgrounds down the middle, another hardware war raged. On one side, the Commodore 64 – powerful, but expensive. On the other, the ZX Spectrum – with less under the hood, but sold for a much friendlier asking price.

Made by inventor Sir Clive Sinclair's Sinclair Research, the ZX Spectrum arrived in April 1982, ahead of the C64, and with its low price it quickly became the most popular home computer in Britain. In the US, the C64 would clean up, but across the Atlantic, the ZX Spectrum ruled.

The Spectrum wasn't Sinclair's first computer, but it was the first to display colour, hence its name. Promoted with claims of 'massive RAM' – 16KB and 48KB models were available – the ZX Spectrum stood apart from competitors due to its rubber keyboard, rainbow stripe and diminutive dimensions. It confidently proved that size didn't matter, whether in terms of scale or software, and Sinclair would ultimately sell around 5 million units.

The rivalry between Sinclair's computers and competitor BBC Micro inspired the 2009 BBC drama *Micro Men*. In it, Sir Clive, played by Alexander Armstrong, tells his team: 'Price is the key.' And truthfully, that was the key to the Spectrum's success.

COMMODORE 64

Despite the popularity of the Spectrum – and its massive software library, with around 3,400 titles by 1984 – Sinclair's machine wasn't actually optimized for video games. Commodore thought differently.

Commodore was founded in the US by Jack Tramiel, a Polish immigrant who'd moved to the States after surviving Auschwitz during the Second World War. His first product to bear the Commodore name was a typewriter. Later came calculators. And then, in 1977, the company released its first computer, the Commodore PET.

The PET was the foundation of Commodore's line of 8-bit computers. 1980's VIC-20 followed – the first computer to sell a million units – and in the summer of 1982 came the Commodore 64. Designed to be accessible to a public tentatively exploring home computers, the C64 – the '64' indicating how much RAM it had – was a phenomenon. By the time it was discontinued in 1994, about 17 million units had been sold, making the C64 the highest-selling computer model of all time.

While the C64 wasn't explicitly a video-games system, it had been designed with games in mind, and was able to use animated sprites for visuals and featured advanced sound processing. And that extra power was a boon to developers too, with the C64's impressive amount of memory paving the way for some very special games.

WHAT IS RAM, ANYWAY?

When it comes to RAM – random-access memory – the number (16, 64 and so forth) indicates how much data, in kilobytes, can be stored in the computer's short-term memory. In theory, the higher the RAM, the better your computer can run games. Essentially, the Commodore 64 contained four times the RAM of the 16KB ZX Spectrum, offering more advanced visuals, smoother scrolling and better music and sound.

Did that make it the superior system? Not necessarily. The Spectrum's cheaper price and volume of games made it the mass-market winner in Britain. Writing on the Eurogamer website in 2012, journalist Julian Rignall compared the Spectrum to a Volkswagen Beetle, and the C64 to a Cadillac – both get you around just fine, but one is clearly more of a luxury model.

ELITE

While not originally developed for the Spectrum or the C64, *Elite* – designed by David Braben and Ian Bell while at university – was extensively ported after debuting on the Acorn Electron and BBC Micro in 1984. It earned rave reviews from Spectrum and Commodore publications, and around 600,000 copies were sold across all formats.

That might not sound like a lot compared to modern bestsellers. But *Elite*'s legacy is based more on its stunning design than any profits it made. Using wireframe graphics to deliver 3D visuals and procedural generation to create eight galaxies, each with 256 planets, the space-trading game was literally enormous. Video games hadn't existed on this scale before.

The freedom of exploration that *Elite* afforded the player inspired a raft of games, including *Grand Theft Auto* and *No Man's Sky*. Speaking to *VICE*

in 2016, *No Man's Sky* director Sean Murray noted: 'It's almost like we've gone back to [*Elite*]. We're trying to explore ideas about openness, and

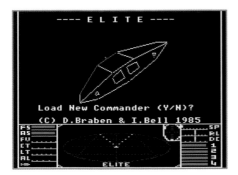

vastness, and freedom.' If you play almost any open-world game today, chances are its makers learned a thing or two from *Elite*.

DIZZY

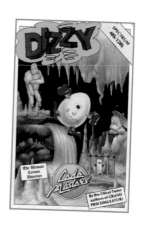

Designed by the Oliver Twins, Andrew and Philip, *Dizzy* is an egg with a face, shoes and boxing gloves. A little weird, maybe, but *Dizzy* games, almost exclusively platformers, were among the most popular developed for the Spectrum and C64.

The *Dizzy* franchise started with 1987's *Dizzy – The Ultimate Cartoon Adventure*. A watershed release for the Spectrum, *Your Sinclair* magazine named it the fifth best game on the computer. It was followed by 1988's *Treasure Island Dizzy*, 1989's *Fantasy World Dizzy* and 1990's *Magicland Dizzy*. By 1991, *Dizzy* titles had sold half a million units, and games and remakes featuring the anthropomorphized egg have been released into the twenty-first century.

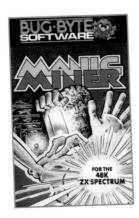

MANIC MINER AND JET SET WILLY

One of the ZX Spectrum's earliest essentials, and its first release to have in-game music, 1983's *Manic Miner* is a platformer where time itself is pitched against the player.

The protagonist, Miner Willy, has to escape underground caverns before he runs out of air, while avoiding spiders, slime and killer robots. *Manic Miner*'s reputation as a great of its era was highlighted as recently as 2017, when the gaming website Polygon named it the 97th best video game of all time.

It spawned a sequel in 1984's *Jet Set Willy*, which sees Willy hosting a wild party in his new mansion, and having to tidy everything up before he can go to bed. Not much of a plot, it's true, but the same great gameplay was carried over from *Manic Miner*, and *Jet Set Willy* topped Spectrum sales charts for several months.

SKOOL DAZE

A video game set in school might not have seemed immediately appealing, but 1984's *Skool Daze* was both a lot of fun and an important release for the evolution of gaming.

The player controls troublemaker Eric, who has to steal his report card from the staff room. If he gets caught misbehaving too often, he's expelled. But it's the game's freedom that's important. *Skool Daze* allows Eric to roam around his environment, interacting with other pupils and teachers. It's seen as a pioneering release in 'sandbox' gaming, a progenitor of *The Sims* and *Minecraft*.

KNIGHT LORE

Developed by British, Leicestershire-based Ultimate Play The Game – the studio headed by the Stamper brothers, Chris and Tim, before they founded Rare – *Knight Lore* was an action-adventure game that showed the Spectrum could surprise with its visuals, despite the system's limitations.

Using isometric perspective, *Knight Lore* achieves a convincing 3D effect. Its monochromatic graphics manifest a palpable atmosphere, as the character of Sabreman

explores a mysterious castle in search of a cure for his lycanthropy,
contracted via a bite from the supernatural Sabre Wulf (the main enemy
of a game of the same name), and causing him to become a werewolf

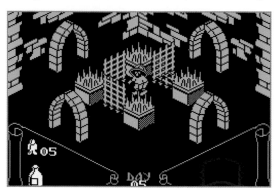

every night.

Named game of the year at the 1984 Golden Joystick Awards, *Knight Lore* is an iconic release in British gaming.

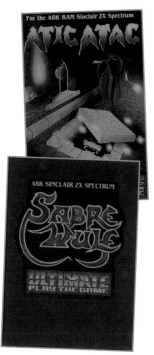

ATIC ATAC AND SABRE WULF

Ultimate Play The Game became a developer of note for the ZX Spectrum. Before *Knight Lore*, it put out two other certified classics: *Atic Atac* and *Sabre Wulf*.

Sabre Wulf is a direct predecessor to *Knight Lore*, released in 1984 and starring the same character, Sabreman, this time in a 2D maze-like environment. It was the first of four games to star the protagonist, who became something of a studio mascot.

1983's *Atic Atac* is, like *Knight Lore*, set in a castle, but uses a top-down visual approach. The player has to find three pieces of a key to escape. The game served as inspiration for *Knightmare*, a popular British TV show of the 1980s.

EARLY '80S HOME COMPUTER CONTENDERS

BBC MICRO
Launched: 1981
Discontinued: 1994
Three to play: *Elite, Granny's Garden, Repton*

DRAGON 32/64
Launched: 1982
Discontinued: 1984
Three to play: *Manic Miner,
Football Manager, Chuckie Egg*

ACORN ELECTRON
Launched: 1983
Discontinued: 1985
Three to play: *Thrust, Starship Command,
Exile*

AMSTRAD CPC
Launched: 1984
Discontinued: 1990
Three to play: *Chase H.Q., Prince of Persia,
Head over Heels*

INTERNATIONAL KARATE +

It's easy to look at the likes of *Street Fighter II* and *Mortal Kombat* as the first fighting games of significance. But if you had a Spectrum or C64 in 1987, System 3's *International Karate +* was the go-to for virtual fisticuffs.

Whether playing solo or with a friend, *IK+* features three fighters on screen at once, with the top two qualifying from each round. Knockouts don't matter – it's all about scoring six hits, first.

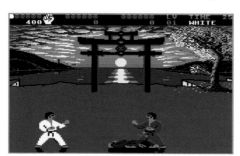

The game makes fun use of the keyboard too: pressing 'T' drops fighters' trousers. Naturally, said key took plenty of punishment.

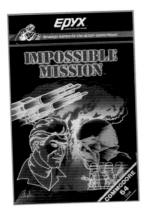

IMPOSSIBLE MISSION

First released for the C64 in 1984, Epyx's *Impossible Mission* riffs on the *Mission: Impossible* TV show, casting the player as a secret agent attempting to thwart the plans of the evil Professor Elvin Atombender (and what a name that is).

Rather than starting with a number of lives, the player begins with six hours on the clock, each death reducing the time remaining by ten minutes. The goal is to break into Atombender's control room by cracking passcodes.

Voted by readers of *Zzap!64* magazine as the best game on the C64, *Impossible Mission* received several ports, but it's the Commodore version that forged its reputation.

MANIAC MANSION

Graphic adventure games – story-based affairs, often with gentle puzzles – arguably started with On-Line Systems' (later named Sierra On-Line, Inc) *Wizard and the Princess*, in 1980. Rather than being entirely text-based, these games also incorporated visuals. But by the time of 1987's *Maniac Mansion*, the genre had really hit its stride.

Designed by Ron Gilbert and Gary Winnick at Lucasfilm Games, *Maniac Mansion* pioneered the SCUMM game engine, which placed command verbs on the bottom of the screen, to be used in conjunction with the scene above. So, click 'Walk to', and then on a door, and your character would oblige. *Maniac Mansion* combined innovative and intuitive controls – the SCUMM system would be utilized several times after this debut – with a hilarious script, and gave birth to the now-standard 'point and click' interface for games of its style.

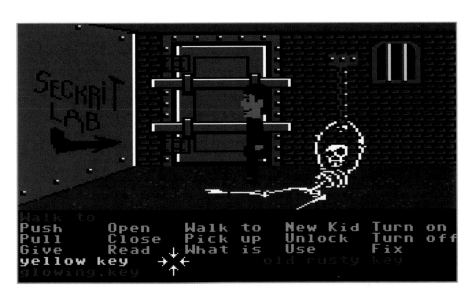

3 NINTENDO ENTERTAINMENT SYSTEM

BEFORE THE NES

Before the NES, Nintendo was far from being a household name. But Nintendo didn't begin with the NES. The company had already been trading for almost a century before the iconic console's release.

Nintendo was founded in Kyoto in 1889 to produce playing cards, specifically ones in the *Hanafuda* style, used for games like *Koi-Koi*. Today, Nintendo still manufactures these cards in Japan, alongside its video-game products. But in the 1950s and '60s, Nintendo diversified. It set up a taxi company, a food business and chain of love hotels (yes, the short-stay kind). None of these took off – until, in the 1970s, Nintendo entered the world of electronics.

After licensing the Magnavox Odyssey for Japanese retail, Nintendo's first original hardware was 1977's Color TV-Game series of consoles with pre-installed games. Arcade cabinets followed with the likes of *Space Firebird* and *Donkey Kong* – and then came the Game & Watch range of handheld LCD games, which achieved global success in the early 1980s.

Game & Watch would evolve into the Game Boy – both were designed by long-term employee Gunpei Yokoi. But before the Game Boy became our faithful travel companion, the NES revitalized the struggling gaming industry.

NES TO THE RESCUE

The 8-bit Nintendo Entertainment System – released as the Family Computer (Famicom) in Japan, with a different design – reached stores around the globe in 1985 and '86. With over 61 million units sold, it brought both big profits and consumer confidence back to gaming following the industry's 1983 crash.

The NES was a particular hit in North America – over half of those 61 million sales were to US and Canadian customers. For the worldwide launch, Nintendo dropped mentions of 'computer' and 'video game' in light of the fatigue that had caused the 1983 crash. The 'Nintendo Entertainment System' name was a very deliberate choice, as was the use of 'Pak' for game cartridge, and 'Control Deck' instead of console.

The NES was primarily sold as a toy – and the inclusion of the Robotic Operating Buddy, or R.O.B., helped convince stateside retailers that this was a technologically advanced plaything, not a product comparable to what Atari was offering.

The NES soon dominated the gaming market, selling as many units in 1988 as the Commodore 64 achieved in its first five years. It didn't outsell its rivals in every market, but on a global scale, nothing could touch the NES's popularity.

MARIO BROS.

The Famicom's domestic launch in Japan preceded its international rollout by two years, releasing in 1983. It was a natural home for Nintendo's arcade games – among them *Mario Bros.*, a two-player platformer that helped define who Mario (who would later become the company's mascot) actually was, in both his appearance and his abilities.

A design collaboration between company legends Yokoi and Shigeru Miyamoto, *Mario Bros.* set a number of precedents. Miyamoto gave Mario the profession of plumber – which made sense, given the game's enemy-spawning pipes. *Mario Bros.* also brought the debut of Mario's brother, Luigi – just a palette swap, but he would become one of Nintendo's most popular characters.

SUPER MARIO BROS. AND DUCK HUNT

If you bought a NES in the US or Europe, there's a good chance that *Super Mario Bros.* came bundled with it. And depending *when* you bought it, you might've also got a bonus game that used the Zapper light-gun: *Duck Hunt.*

Super Mario Bros. and *Duck Hunt* were compiled on one Pak in 1988, though they'd been available separately before then. 1985's *Super Mario Bros.* is the classic, the cornerstone release, the game that pioneered the *Mario series'* scrolling, platforming action spread across a sequence of worlds and stages. Additionally, it effectively confirmed Mario as the virtual face of Nintendo.

Super Mario Bros. also introduced two of the mainstay characters of the franchise – Princess Peach (Princess Mushroom, back then), and Mario's famous antagonist, Bowser. It also marked the debut of the iconic *Mario* theme tune, its earworm melodies composed by Koji Kondo.

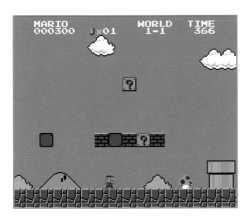

But *Duck Hunt* shouldn't be forgotten. Great fun, its hunting-dog character has appeared in later Nintendo games, as well as in the (not-so-great) movie *Pixels*.

IT'S-A ME, MARIO!

Designed by Miyamoto for *Donkey Kong*, the character that would become Mario was initially called Jumpman in English-speaking markets, and was briefly set to be called Mr Video. His name came from the landlord of a warehouse that Nintendo of America used, and his eventual profession, plumber, was inspired by the sewer pipe visuals of the *Mario Bros.* games.

But why does he look like that? It's all down to the limitations of the hardware available to Nintendo at the time. His red and blue colours contrasted clearly against the black backdrop of *Donkey Kong*, and giving him a cap meant that they didn't have to design a hairstyle. His head, meanwhile, had to fit into a square of only 8x8 pixels, hence the pronounced nose and moustache as his only significant features. Behold: it's-a Mario.

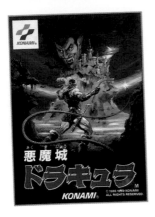

CASTLEVANIA

Today, the *Castlevania* franchise encompasses not only games spanning several console generations, but also comic books, collectible figures and a Netflix animated series. But it all started with 1986's *Castlevania*.

First released for the Japan-only Famicom Disk System, the Konami-developed *Castlevania* is an action-packed platformer casting the player as vampire hunter Simon Belmont. The aim of the game is to defeat the master of its spooky castle setting, Dracula himself.

The simple story is made memorable by compelling level design and a steep difficulty curve, as well as a slightly cheesy horror setting. The game also introduced the curious gaming phenomenon of finding health-restoring roast chickens hidden within the environment, in this instance inside breakable walls. (Similar poultry-based perks can be found in Capcom's *Final Fight* and SEGA's *Streets of Rage*.)

Later sequels would prove better games, but the first *Castlevania* will always be a NES essential.

THE LEGEND OF ZELDA

Shigeru Miyamoto, who joined Nintendo in 1977, is the designer and producer of several much-loved Nintendo series, including *Donkey Kong*, *Mario* and *Pikmin*. But Miyamoto's most important work might be 1986's *The Legend of Zelda.*

The Legend of Zelda was an open-world adventure game for the Famicom Disk System and NES that *didn't* funnel the player from left to right, or along enemy-stuffed corridors. It wasn't about high scores or first-place finishes, it was about exploration – seeing what was over the next hill. Or, in this case, what was on the next screen.

As a child, Miyamoto loved to explore the area around his home – woods, fields and even caves. Those memories, that sense of imagination, is clear to behold in *The Legend of Zelda*, as the player guides protagonist Link through a coming-of-age journey on which he discovers his heroic destiny. It is, quite simply, the forefather of all role-playing games, or RPGs.

35

THE KONAMI CODE

Konami was one of Nintendo's closest third-party partners in the NES era, porting several arcade hits onto the platform alongside games developed exclusively for the system such as *Castlevania* and *Metal Gear*.

Two of these ports were 1985's sci-fi shooter *Gradius* and 1987's run-and-gunner *Contra*. Both were well received on the NES, but they've earned their places in history due to the early inclusion, in both, of what became known as the Konami Code – one of gaming's earliest (and certainly most famous) cheat codes.

This sequence, usually input on the title screen, made tough games a lot easier. And the same commands – up, up, down, down, left, right, left, right, B, A – would unlock perks, bonuses and Easter eggs on countless future Konami games.

METROID

Another NES game that originally debuted on the Famicom Disk System, *Metroid* – like *The Legend of Zelda* – wasn't about shooting a certain number of enemies, but instead focused on exploration, atmosphere and the acquisition of power-ups.

Usually, the new abilities would enable the protagonist, Samus Aran, to access previously unreachable areas. Her quest: to destroy Mother Brain, the orchestrator of the game's villainous Space Pirates.

Metroid's unsettling ambience, non-linear game world, emphasis on discovery and end credits reveal – that Samus is a woman, a rarity for action heroes in the 1980s – ensured its classic status from day one. Combined with the *Castlevania* series' similarities, its key gameplay features coined a subgenre still in use to describe newer titles – such as *Cave Story*, *Hollow Knight* and *Axiom Verge* – with comparable qualities: Metroidvania.

THE NES'S BEST AND WORST PERIPHERALS

R.O.B.
What was it? A robot-shaped controller that interacted with two games: *Stack Up* and *Gyromite*
Useful? An hour after opening it, not really
Legacy? Despite its limited use, R.O.B. helped the NES sell in the US, and has since appeared as a character in *Super Smash Bros.* and *Mario Kart*

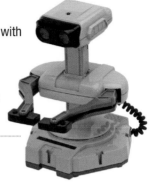

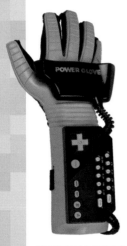

POWER GLOVE
What was it? A slip-on controller that theoretically worked with any NES game, but was specifically only used for *Super Glove Ball* and *Bad Street Brawler*
Useful? As an accessible controller, utterly, hopelessly not
Legacy? The Power Glove sold a million units after featuring in the 1989 Nintendo-backed movie *The Wizard*, but has been the butt of jokes ever since

KONAMI LASERSCOPE
What was it? A head-mounted light-gun designed for one game in particular, *Laser Invasion*, but it'd work with any light-gun title, including *Duck Hunt*
Useful? Pretty much the opposite
Legacy? Voice-activated, but with an awful microphone, the LaserScope was junk that only succeeded in making the user look very, very silly

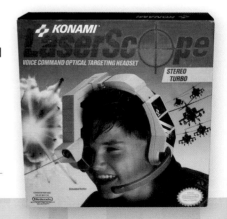

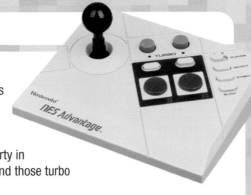

NES ADVANTAGE

What was it? An arcade joystick and buttons that worked with just about every NES game
Useful? If your hands are too chunky for the control pad, absolutely
Legacy? It's used to steer the Statue of Liberty in *Ghostbusters II*, so it's basically legendary (and those turbo buttons are useful too)

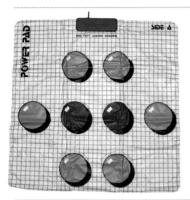

POWER PAD

What was it? A dance mat with pressure sensors used for *World Class Track Meet* and a few Japan-only games based on *Takeshi's Castle*
Useful? About as much as any mat for home consoles (which is to say, its usefulness is strictly limited)
Legacy? *Dance Dance Revolution* definitely borrowed a trick or two from the Power Pad

U-FORCE

What was it? An infrared sensor meant to interpret hand motions – playing without touching anything, making *you* the controller
Useful? As landfill, maybe
Legacy? Despite being ahead of its time, the U-Force sadly didn't work *most* of the time, and is one of the worst controllers ever made

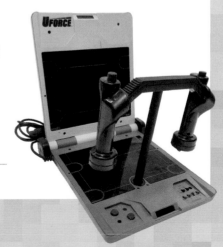

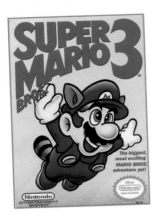

SUPER MARIO BROS. 3

Taking away the first wave of console-bundled games, *Super Mario Bros.* (over 40 million sold) and *Duck Hunt* (over 28 million), 1988's *Super Mario Bros. 3* is the NES's highest-selling release, shifting 18 million copies.

And with good reason too, as it's one of the most instantly enjoyable video games ever made. Key development personnel Shigeru Miyamoto and Takashi Tezuka wanted *Super Mario Bros. 3* to both build on previous *Mario* gameplay tenets, thus providing familiarity alongside new challenges, and keep newcomers entertained. To help beginners, early levels drop more extra lives than previous titles, keeping them invested for longer.

Regarded as the finest game of its era by countless critics, the colourful and charming *Super Mario Bros. 3* has aged extremely well. Widely available on contemporary Nintendo consoles, it remains the template for many modern 2D platformers.

DOUBLE DRAGON

While not an exclusive title, *Double Dragon* found a sizeable audience on the NES. However, Technōs Japan's popular arcade beat 'em up changed its plot for the home port, ultimately pitting twin brothers Jimmy and Billy Lee against each other, whereas they'd fought together in the original.

This alteration was necessitated by the hardware limitations of the NES – and Technōs' inexperience with porting to it. Enjoyed well enough by kids who didn't know better, with hindsight it's easy to regard the NES version of *Double Dragon* as a buggy mess in comparison to other versions. Nevertheless, it was a big seller and is fondly remembered.

A NEW NES

After the American release of the Super Nintendo (SNES) in 1991, Nintendo didn't want to completely abandon its 8-bit library, with consumers aplenty preferring the older games. So in 1993 it launched the NES-101, aka the New NES or Top Loader (for obvious reasons), a dramatic redesign of the NES with new 'dog bone' control pads priced at just $49.99, encouraging those looking for cheaper thrills to stick with Nintendo products.

In Japan it got a further makeover, and was released as the AV Famicom, or model HVC-101. The Famicom model actually remained in production until 2003, five years after Nintendo had discontinued the SNES in Europe, effectively giving the NES a lifespan of twenty years.

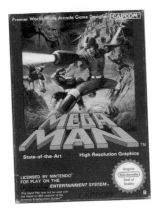

MEGA MAN

Mega Man 2 and *3* are among the NES's bestselling games. But the Mega Man character – aka the Blue Bomber, aka Rockman, who still appears in new games today – naturally debuted with the original *Mega Man*, released for the NES in 1987.

Mega Man (called *Rockman* in Japan) was Capcom's first title made specifically for home consoles, the company having made its name with arcade hits like *Ghosts 'n Goblins*. A scrolling action-platformer, *Mega Man* combines bold visuals and dazzling weapons with a stiff challenge. Its first six levels can be played in any order, the final one unlocking once they've been completed, where final boss Dr. Wily awaited.

Mega Man didn't sell brilliantly, but Capcom's confidence in its character and gameplay saw sequels follow, and the rest is history.

TEENAGE MUTANT NINJA TURTLES

Not to be confused with the arcade version of *Teenage Mutant Ninja Turtles* – which was also developed by Konami, with both games released in

42

1989 (and be sure to replace that *Ninja* in the title for *Hero*, in the UK) – this NES original cashed in on the popularity of the Turtles, who'd graduated from comics to a hit TV cartoon series. Sales were high, but the critical reception to *Turtles* on the NES wasn't so positive.

Unpolished and unforgivingly hard, *Teenage Mutant Ninja Turtles*, for all of its pizza-munching action, was a disappointment for fans of the heroes in half-shells. Thankfully for NES owners, Konami's arcade version was ported over in 1990 – so if you only play one of the two today, make sure it's the one that was conceived as a coin-op.

MICRO MACHINES

Despite brilliant versions being released on the SEGA Mega Drive and Commodore Amiga, the top-down racing of *Micro Machines* actually made its debut on the NES in 1991. Not that *Micro Machines* on the NES was a slouch when it came to addictive qualities, with its clear sprites and slick gameplay making for many a glorious afternoon spent with pals in front of the television.

Micro Machines was developed by British studio Codemasters without a licence from Nintendo, resulting in legal obstacles that ultimately compromised its NES sales. The company had a similar situation with SEGA, which delayed the game's Mega Drive release. But by 1995, *Micro Machines* was on almost every major platform available, and acclaimed across the board.

BEFORE THE MASTER SYSTEM

SEGA's business has always been gaming. The company as it is today was founded in 1960, as Nihon Goraku Bussan, becoming SEGA Enterprises Ltd in 1965. Headquartered in Tokyo, SEGA's roots stretch back to the coin-operated games of the 1940s – pinball tables and light-gun cabinets – but it found its breakthrough successes during the arcade boom of the late 1970s and early '80s.

Arcade hits like *Head-On* (a precursor to *Pac-Man*), *Monaco GP* and *Turbo* would make SEGA a famous (and wealthy) brand. But when revenues dipped in 1982, in line with global trends, a change of direction was necessary, and then-president Hayao Nakayama approved the manufacture of a home gaming system.

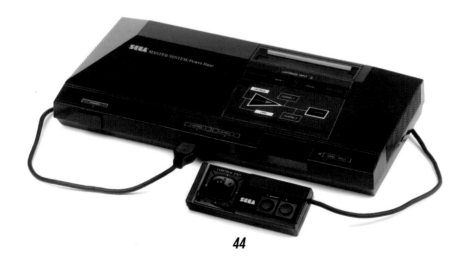

The company's first console was 1983's Japan-only SG-1000. An 8-bit machine, in the same generation as the Famicom/NES and launched on the very same day, it failed to rival Nintendo's console. An update came out in 1984, the SG-1000 II, but with Nintendo trouncing SEGA's sales, a third revision was necessary.

That console launched in Japan in 1985 as the SEGA Mark III. Despite superior sound and graphics compared to its predecessors – as well as the Famicom – the Mark III failed to make a significant domestic impression. Nintendo had Japan wrapped up, so SEGA looked overseas.

MASTER SYSTEM VS NES

The SEGA Mark III (below) followed the Famicom's lead when it came to its international launch by changing its name. Rebranded as the Master System (opposite), courtesy of some fairly random decisions at SEGA of America (apparently names were put on a wall, and darts tossed at them), and given an external redesign, SEGA's console was ready for the wider world.

But the Master System followed up its Japanese defeat to Nintendo with another underwhelming performance. Launching in North America in 1986, it would sell just 2 million units in the territory compared to the NES, which racked up around 34 million. But in Europe and South America it was a different story.

Rather than directly compete with the NES, European marketeers decided upon a different approach. Virgin Mastertronic, headed by Richard Branson, sold the Master System as the gaming platform to own over the ZX Spectrum or Commodore 64, rather than as a Nintendo competitor. The gambit worked – of the Master

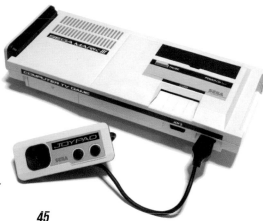

System's total global sales of 13 million, over half were to European customers.

The console also proved incredibly popular in Brazil. Launched in 1989 and distributed by Tec Toy, the Master System had a huge, four-year head start over the NES. Tec Toy continued to manufacture the Master System long after its official discontinuation in 1992, and by 2016 some 8 million units had been sold in Brazil, with the ageing console achieving annual six-figure sales against competition from the PlayStation 4 and Xbox One.

ALEX KIDD

SEGA could see the success Nintendo was having with Mario and wanted a mascot of its own. In time, that'd be a certain blue hedgehog – but before then, there was Alex Kidd.

The star of five platformers (and one racer, *BMX Trial*), starting with 1986's *Alex Kidd in Miracle World* on the Master System and culminating with 1990's *Alex Kidd in Shinobi World*, the jumpsuit-sporting hero was explicitly designed to rival the cap-wearing plumber.

But disappointingly for creator Kotaro Hayashida, who also worked on SEGA's landmark role-playing game *Phantasy Star*, Alex Kidd never fully took off. In 1991 he

was replaced as SEGA's mascot by Sonic the Hedgehog, and has been consigned to cameo appearances ever since.

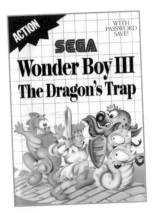

WONDER BOY

Wonder Boy was another of SEGA's 1980s platformer heroes, but his games were generally better than those in the Alex Kidd series. Making his debut in arcades with 1986's *Wonder Boy*, it was with the Master System releases of the second and third games, *In Monster Land* and *The Dragon's Trap*, that the character really hit commercial and critical heights.

The Master System's *In Monster Land* released in 1988, mixing platforming with exploration and role-playing elements – Wonder Boy could upgrade equipment, drink potions and discover treasure. *Wonder Boy III: The Dragon's Trap* followed in 1989, refining the systems of its predecessor, introducing a morphing hero

(who could become, among other things, a mouse and a lizard) and a less linear game world, adopting a Metroidvania layout. The third game received a remake in 2017, earning a new wave of acclaim.

PHANTASY STAR

The first entry in a role-playing series that's never lost its appeal, 1987's *Phantasy Star* felt absolutely huge on the Master System, offering players not just a few levels, or an open world to explore, but a whole planetary system.

Okay, so that system is just three planets, and your party can't explore them extensively. But *Phantasy Star*'s mix of sci-fi themes and medieval fantasy proved intoxicating to players who'd previously been served a steady diet of generic dungeons and dragons.

Star Wars was a major influence on the game, and the team at SEGA flipped the traditional 'damsel in distress' trope by having the game's main protagonist, Alis Landale, be a woman. (Unlike *Metroid*, the game didn't hide this fact until the end.)

Localized into English before the release of the NES's *Final Fantasy*, *Phantasy Star* was many Western gamers' first exposure to story-heavy Japanese role-playing games. Its release on a then-huge 4-megabit cartridge made it a premium product, and the game's scale marked it out as something special.

The game received rereleases on the SEGA Saturn, PlayStation 2 and Nintendo Switch, and the series it kickstarted would deliver genuinely revolutionary experiences, like 2000's *Phantasy Star Online* for the Dreamcast.

CASTLE OF ILLUSION STARRING MICKEY MOUSE

Much like today, a Disney licence in the 8-bit era usually guaranteed impressive sales. And *Castle of Illusion Starring Mickey Mouse*, released for the Master System in 1990, was no exception. But, unlike many of its peers, it's absolutely brilliant.

Two versions of *Castle of Illusion* were released by SEGA – one on the 16-bit Mega Drive, and an 8-bit counterpart on Master System and Game Gear. Both were colourful platformers, but the 8-bit game arguably pushed its hardware more, with detailed visuals and a wonderfully animated Mickey.

OUT RUN

With SEGA's arcade credentials, a number of its popular coin-ops received Master System conversions. These included the motorcycle racer *Hang-On*, pre-installed on some Master Systems; top-down shooter *Action Fighter*; the F-14 combat of *After Burner*; and the surreal shoot 'em up *Fantasy Zone*. Some were better than others, but all these ports were appreciated by gamers who couldn't get to an actual arcade.

The best of SEGA's 8-bit ports, however, was *Out Run*. Designed by Yu Suzuki, who'd go on to direct *Virtua Fighter* and *Shenmue*, it was a racer as much about the journey as the destination, its disparate stages separating it from circuit-based alternatives. The Master System version retained all fifteen stages of the arcade game, plus its three catchy tunes, and was *almost* like having the real thing at home.

SHINOBI

Shinobi was one of SEGA's biggest arcade games of 1987, but it only reached the level of success necessary to spawn several sequels – produced up until 2011 – courtesy of its 1988 Master System version.

Having a home version of Shinobi enabled fans to commit its bosses' attack patterns to memory, without fear of losing all their pocket money. The removal of the arcade game's one-hit deaths was a great relief too. The game's protagonist, the ninja Joe Musashi, also became a minor SEGA mascot, appearing in a few games outside of the *Shinobi* series.

OPERATION WOLF

Just as the NES had its Zapper, SEGA sold a comparable peripheral for the Master System: the Light Phaser. It worked in the same way as the Zapper, using flashes to pinpoint where a shot would land on screen, and SEGA bundled it with consoles containing *Safari Hunt*, its take on *Duck Hunt*.

Still, the Master System's best Phaser game was *Operation Wolf*. The Taito-developed arcade shooter received many home conversions, but it was exemplary on SEGA. Plug a regular controller in alongside the Phaser and you could toss grenades at enemies too. An award-winner, this is the game to turn to when dusting off SEGA's sleek black blaster.

SONIC THE HEDGEHOG

You'll find more on Sonic in the chapter on the SEGA Mega Drive (p. 69), but the company's enduring mascot earns a mention here on account of his 8-bit debut – which also appeared on Game Gear – being every bit as great as the 16-bit version. And yes, they're different games.

It's easy to assume that *Sonic the Hedgehog* for one platform would be essentially the same for the other. But rather than being developed by SEGA's in-house Sonic Team, the Master System game was made by Ancient, a studio co-founded by musician Yuzo Koshiro (more on him in the Mega Drive section too).

Similar to the Mega Drive game on the surface – Sonic runs from left to right, collecting rings and fighting Dr. Robotnik, with a Green Hill Zone at the start – the 8-bit *Sonic*, built from scratch and using none of the 16-bit assets, has many unique elements. Koshiro worked on the game's soundtrack, giving it a very different feel to the Mega Drive title; and a number of levels (and bonus stages) were exclusive to the 8-bit version, such as its Bridge and Jungle zones.

EVEN MORE MASTER SYSTEMS

The Mega Drive launched in Japan in 1988, and support for the Master System quickly dried up there. But with 8-bit games still selling internationally, SEGA needed to keep producing the relevant hardware – so it created a lower-cost second model, imaginatively called the Master System II (below top).

This smaller, less angular version removed the original's reset button and card slot, which was used for only a few games. Then in 1991, SEGA made *Sonic the Hedgehog* the Master System II's built-in game. The move prolonged the 8-bit machine's success in Europe, where it outsold the Mega Drive until 1993.

In Brazil, SEGA's regional partner Tec Toy (now Tectoy) manufactured region-exclusive models including 1992's Master System Compact, 1994's semi-portable Master System Super Compact, and 2008's Master System III (below bottom). Its latest version of the Master System released in 2011, meaning that Tectoy's products extended the console's lifespan to twenty-five years.

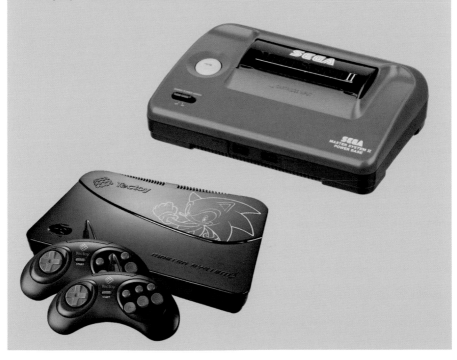

5 HANDHELDS

HANDHELD PREHISTORY: THE MICROVISION

Released by Milton Bradley in 1979, the Microvision is the first portable games system to feature interchangeable cartridges. Its titles – fare such as *Sea Duel*, *Star Trek: Phaser Strike* (aka *Shooting Star*) and *Alien Raiders* – might not be instantly recognizable as games to many of us these days though, comprising little more than a confusing cluster of black dots arranged to crudely represent spaceships and the like.

Despite its extremely primitive visuals and inaccurate touchpad, the novelty of the Microvision saw it earn $8 million in revenue in its first year. But audiences soon turned back to the greater detail and colour of home consoles, and the Microvision was discontinued in 1982.

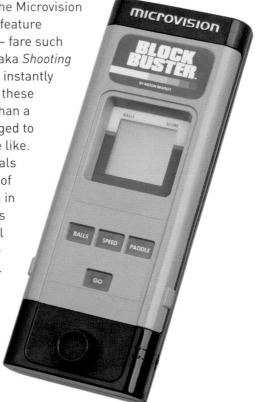

GAME & WATCH

Nintendo's Game & Watch series was the company's first portable gaming project, each unit featuring a single game alongside a clock (hence the name). The range was introduced with 1980's *Ball*, and ended in 1991 with *Mario the Juggler*. Both were juggling games, the aim being to keep objects in the air, separated by eleven years of LCD creativity.

Game & Watch featured super-streamlined takes on famous Nintendo releases, including *Super Mario Bros.* (1986), *Donkey Kong* (1982) and *The Legend of Zelda* (1989). The units came in a variety of models, covering single- and dual-screen games (the latter a precursor to the Nintendo DS), and a two-player Vs. model with minuscule control pads. The range even spawned a mascot, Mr. Game & Watch, debuting in *Ball* before starring in several more LCD titles and, later, Nintendo's *Super Smash Bros.* series.

Game & Watch's lead designer, Gunpei Yokoi, would bring his gaming-

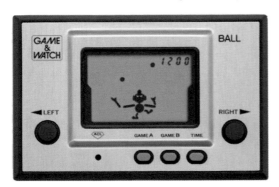

on-the-go experience to his next major project: a proper Nintendo portable console.

NINTENDO GAME BOY

The Game Boy proved that a great console didn't need amazing graphics or sound to succeed. Titles that made the most of the platform mattered, where gameplay ruled and imagination made up for any audio-visual shortcomings.

Gunpei Yokoi's vision was for a lightweight system with clear visuals and games that could be played together by connecting consoles. He also wanted it to be inexpensive, appealing to a wide audience (it launched in

the US at just $89.99). And Yokoi succeeded – although he sadly died in a car accident in 1997, before the Game Boy's legacy could be fully appreciated.

And yet, the console wasn't much liked at Nintendo before release. Employees at the company weren't thrilled by its four shades of green, or its mono speaker (you needed headphones to hear your games in stereo).

But in its favour were three crucial things. First, the Game Boy could run for up to fifteen hours on four AA batteries, whereas its handheld rivals were power-hungry monsters. Second, it launched ahead of any of its rivals, beating the Atari Lynx in the crucial US market by two months, and SEGA's Game Gear by almost two years. And finally, without beginning to consider its other 700-or-so games, the Game Boy had *Tetris*.

TETRIS

The history of block-busting puzzler *Tetris*, the bestselling video game of all time (170 million copies and counting, across all versions), is remarkable. Designed in the Soviet Union by Alexey Pajitnov and first released in 1984, it gradually made its way onto Western home computers. By the late 1980s, multiple publishers claimed they had the right to sell the game – but it was Nintendo's Game Boy that made it a phenomenon.

Long story, very short: Dutchman Henk Rogers snuck into Moscow on a tourist visa in February 1989. He left with an official licence for *Tetris* and with Pajitnov co-founded The Tetris Company to sell the game. Nintendo

bought the exclusive rights for *Tetris* on console and handhelds and immediately bundled it with their new portable system. The Game Boy was a huge hit, *Tetris* was its killer app and the rest is history.

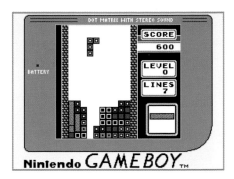

THE CAST OF TETRIS

Believe it or not, the falling blocks of *Tetris* – the tetrominos – have nicknames. And they've each had more than a few, over the years. Here are some favourites, plucked from the weird world of *Tetris* fandom.

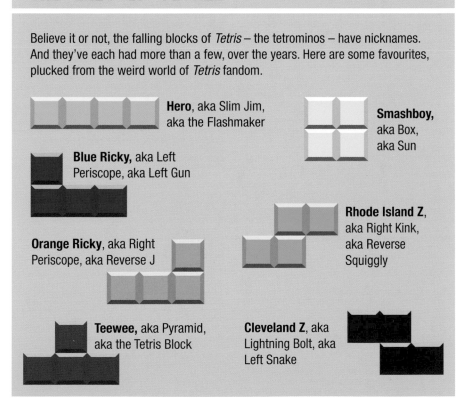

Hero, aka Slim Jim, aka the Flashmaker

Smashboy, aka Box, aka Sun

Blue Ricky, aka Left Periscope, aka Left Gun

Rhode Island Z, aka Right Kink, aka Reverse Squiggly

Orange Ricky, aka Right Periscope, aka Reverse J

Teewee, aka Pyramid, aka the Tetris Block

Cleveland Z, aka Lightning Bolt, aka Left Snake

SUPER MARIO LAND

What's a Nintendo console without a *Mario* game? The Game Boy got its first taste of the platforming plumber with *Super Mario Land*, the 1989 launch title for the portable system. Taking cues from 1985's *Super Mario Bros.*, it's an elementary left-to-right scroller, with coins to collect and pipes to transport Mario to new locations. But the game's simplicity didn't compromise its mass appeal, the tried-and-tested formula helping *Super Mario Land* stack up over 18 million in sales.

Super Mario Land is notable not only for being the first handheld Mario title (Game & Watch excluded), but also for introducing the character of Princess Daisy. It spawned two direct sequels: 1992's more-detailed *Super Mario Land 2: 6 Golden Coins*, featuring the debut of antagonist Wario; and 1994's *Wario Land: Super Mario Land 3*, the first game in which the yellow-and-purple villain became a playable character.

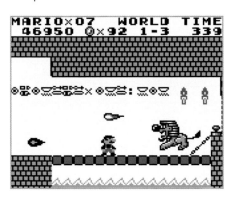

POKÉMON

The global megabrand of Pokémon began as a pair of Game Boy releases – *Pokémon Red* and *Pokémon Green* – issued in Japan in 1996. Their launch day, 27 February, is now observed as Pokémon Day, with worldwide events held to celebrate the existence of the pocket monsters.

Pokémon Blue followed shortly after *Red* and *Green* in Japan, and come the games' international releases in 1998, it was *Red* and *Blue* that led the way, with the Pikachu-focused *Pokémon Yellow* not

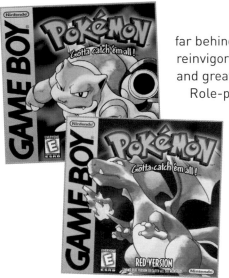

far behind. The games' impact was instant, reinvigorating sales of the ageing Game Boy and greatly prolonging its shelf life.

Role-playing games that offered both solo and shared fun – players could trade Pokémon via the Game Boy's link cable – *Red* and *Blue* earned strong reviews and eventually set a Guinness World Record as the bestselling RPG of all time (assessed collectively).

Red and *Blue* were remade as *FireRed* and *LeafGreen* for the Game Boy Advance in 2004, and

ORIGINAL GAME BOY TOP TEN

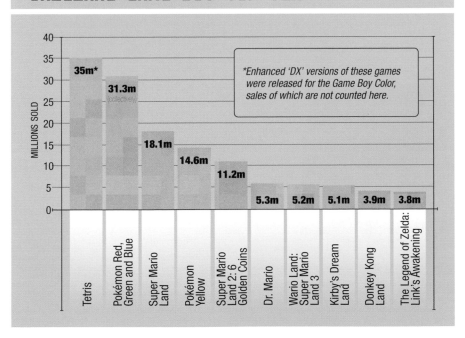

*Enhanced 'DX' versions of these games were released for the Game Boy Color, sales of which are not counted here.

MILLIONS SOLD

Game	Millions Sold
Tetris	35m*
Pokémon Red, Green and Blue	31.3m (collectively)
Super Mario Land	18.1m
Pokémon Yellow	14.6m
Super Mario Land 2: 6 Golden Coins	11.2m
Dr. Mario	5.3m
Wario Land: Super Mario Land 3	5.2m
Kirby's Dream Land	5.1m
Donkey Kong Land	3.9m
The Legend of Zelda: Link's Awakening	3.8m

the originals (including *Yellow*) were released digitally on the Nintendo 3DS Virtual Console service in 2016, selling an impressive 1.5 million copies a full twenty years after they debuted.

Yellow was remade as the Switch-only title *Pokémon: Let's Go* (available in two versions, *Let's Go, Pikachu!* and *Let's Go, Eevee!*) in November 2018. Benefitting from a complete audio-visual overhaul, as expected for a twenty-first century revision, and incorporating gameplay elements from *Pokémon GO* (as well as some integration with it, as critters could be transferred), it had sold 10 million copies by the end of that year, showing that the core gameplay of the Game Boy *Pokémon* titles – catch 'em all (and then have them fight each other) – hadn't aged at all.

KIRBY'S DREAM LAND

While a lot of Nintendo's most recognizable characters began their stories on home consoles, Kirby's first appearance was in the Game Boy-exclusive *Kirby's Dream Land* of 1992. With over twenty standalone games and 34 million in sales, *Kirby* is today one of Nintendo's most profitable franchises.

The curious pink blob was created as an exercise in simplicity: designer Masahiro Sakurai of HAL Laboratory needed a placeholder character for a new platform game, *Twinkle Popopo*. He drew a circle, gave it facial features and some stubby limbs, and that was that.

The draft was always meant to be replaced by a more complex character, but Sakurai fell in love with his rotund creation. Kirby was born, and *Twinkle Popopo* became the stress-free, float 'em up *Kirby's Dream Land* – a hit for HAL, Nintendo and the Game Boy.

THE LEGEND OF ZELDA: LINK'S AWAKENING

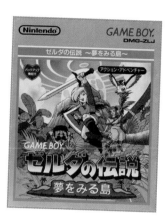

It started as a Game Boy remake of the Super Nintendo's *The Legend of Zelda: A Link to the Past*, but became a singularly surreal adventure all of its own, and one of the most warmly remembered *Zelda* games of the series' early years.

Inspired in part by the TV show *Twin Peaks* – which accounts somewhat for its general weirdness – *Link's Awakening* was released in 1993 to critical acclaim. Its limited visuals do nothing to prevent the player from being absorbed by the captivating game world – and this isn't the Hyrule we know from previous *Zelda* adventures. This is something very different, with no Princess Zelda or Triforce to be found.

By the end of the game – spoiler alert! – it transpires that the events of *Link's Awakening*, played out on Koholint Island, have existed solely in the hero Link's head, while he's been drifting at sea. But while its story and

setting might've been ephemeral in the grand scheme of *Zelda* games, *Link's Awakening* left a lasting impression, and in 2019 a remake was announced for the Nintendo Switch.

PORTABLE POWER, POWERED UP

The monochrome Game Boy was revised twice during its lifespan, with a Pocket version in 1996, which brought the console's battery requirements down to a pair of AAAs, and the Light in 1998, which finally added a backlight but was only released in Japan.

Nintendo livened up its handhelds' visuals in October 1998 with the Game Boy Color, which effectively competed against the black and white of its own Pocket with both Atari and SEGA out of the picture. Backwards-compatible with original Game Boy cartridges, the Color's sales, added to the previous range's totals, make the Game Boy 'family' the third bestselling console of all time.

Launched in 2001 and ultimately released in three distinct models, the Game Boy Advance maintained the brand's market dominance. The first GBA model had controls set on either side of a central screen, whereas 2003's SP version featured a clamshell case, which opened up to resemble the layout of older Game Boys, and a backlit screen, which the previous version oddly lacked. Then came 2005's Micro, which as its name implies was a very small system, indeed. Don't play it near a drain.

The GBA's 32-bit games were richly detailed like no portable titles before them, and all models except the Micro could play Game Boy and Game Boy Color releases too. This

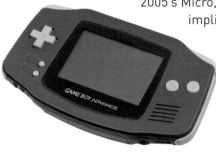

meant owners could take *Tetris* and *Super Mario Land* around with them, as well as GBA classics like *Advance Wars*, *Metroid Fusion* and the latest *Pokémon* series entries, *Ruby* and *Sapphire*. The massive software library made the Game Boy Advance one of the greatest consoles ever produced, capable of playing games released from 1989 to 2010, the year it was officially shuttered.

SEGA GAME GEAR

With SEGA and Nintendo fiercely competing throughout the 1980s and '90s, it was inevitable the former would produce a competitor for the latter's monochromatic triumph. Unfortunately, the SEGA Game Gear – though offering the novelty of full-colour visuals – didn't catch on like the dominant Game Boy.

Launched in Japan in 1990, and Europe and North America in 1991, the Game Gear was essentially a portable SEGA Master System. It went through batteries at a rapid rate, depleting six AAs in just three hours, and never developed the exclusives-aplenty software library that the Game Boy enjoyed.

In fact, many of SEGA's 8-bit games were made for both Game Gear and the Master System. This meant the Game Gear *did* have some greats – the 8-bit *Sonics* are fantastic, likewise

Castle of Illusion and *Wonder Boy III: The Dragon's Trap*. But its pack-in puzzle game, the match-3 stack 'em up *Columns*, couldn't compare to the addictive *Tetris*, and a series of Mega Drive ports, including *Gunstar Heroes* and *Streets of Rage 2*, just didn't work on the small screen.

The Game Gear was discontinued in 1997, just as *Pokémon* was giving the Game Boy a new lease of life. Its sales totalled around 10.6 million – a drop in the ocean compared to the Game Boy range's 118 million. SEGA didn't immediately duck out of the handheld market, producing the North America-exclusive Nomad in 1995. The portable Mega Drive fared even worse commercially, though, and SEGA never produced another portable once Nomad production was ended in 1999.

ATARI LYNX

Atari, without a true hit console since the 2600, released the Lynx in 1989, a few months after the Game Boy.

Like Game Gear, it had colour graphics, but its selection of games was even less impressive than SEGA's. Despite a few innovations – notably a button layout that enabled the system to be flipped horizontally, putting the directional pad on the left or right – the Lynx never gained a following, selling only 3 million units in six years.

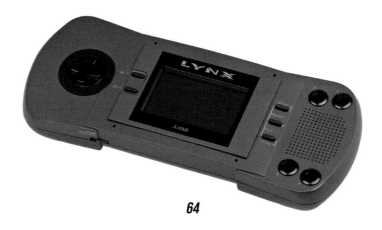

THE GOOD, THE BAD AND THE UGLY OF HANDHELDS

NEO GEO POCKET COLOR
Released: 1999
Discontinued: 2001
Verdict? Good!
Why? A forty-hour battery life, a fantastic thumb stick and a superlative range of fighting games have given the Pocket Color cult status among console collectors.

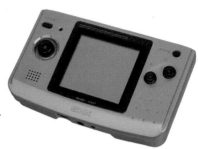

GAMATE
Released: 1990
Discontinued: 1994
Verdict: Bad!
Why? Its green screen pitched it into competition with the Game Boy but was so blurry that few Gamate releases – many of which were clones of other games – were satisfyingly playable.

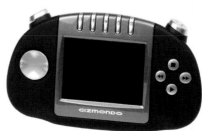

GIZMONDO
Released: 2005
Discontinued: 2006
Verdict: Ugly!
Why? One of the directors behind this Swedish console, Stefan Eriksson, was a member of the Uppsala mafia, and its makers declared bankruptcy within a year, having gone some $300 million into debt.

6 SEGA MEGA DRIVE / GENESIS

FROM 8- TO 16-BIT

The Nintendo Entertainment System (Famicom) and SEGA Master System (Mark III) became the go-to consoles of the 8-bit era. Then in 1987, game-makers ushered in a new era with the launch of the first 16-bit console. Well, what *seemed* like the first 16-bit console.

NEC's PC Engine debuted in Japan in October 1987. It rivalled the Famicom domestically, and outsold Nintendo's 8-bit machine in its first year. It would earn significant acclaim, with IGN in 2009 naming it the thirteenth best console of all time, and *Retro Gamer* readers in 2018 ranking it twenty-fourth.

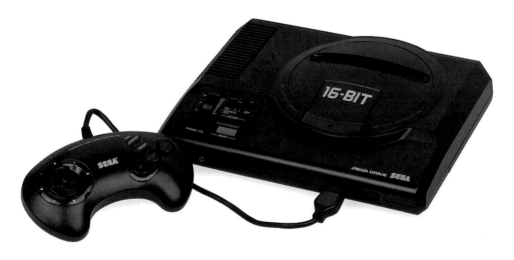

But America wasn't convinced. Rebranded as the TurboGrafx-16 Entertainment SuperSystem, the PC Engine landed in the US in summer 1989, when SEGA's Mega Drive – known as the Genesis in North America due to a regional trademark dispute – was already in stores. The Genesis really was a 16-bit console, with better sound and visuals than 8-bit systems, while the TurboGrafx-16 had an 8-bit CPU paired with a 16-bit graphics processor (hence the name). Essentially a transitional console, the TurboGrafx-16 was met with suspicion and sold poorly, leaving the US market wide open for SEGA's and Nintendo's next-generation systems.

HOMELAND HESITANCE

The SEGA Mega Drive was launched in Japan in October 1988, the same month as Famicom's *Super Mario Bros. 3*. So, despite representing a generational leap, the Mega Drive was eclipsed by Nintendo's platformer.

It never recovered domestically. When the Mega Drive was discontinued in 1997, it had sold 4.3 million units in Japan. In comparison, the Super Famicom had sold over 17 million and the PC Engine 8 million. That would have been a disaster after the Mark III/Master System – but belatedly, America fell for SEGA, and in a big way.

MEGA SUCCESS IN AMERICA AND EUROPE

SEGA's aggressive marketing in the US caused a stir, with one slogan entering gaming history: 'Genesis does what Nintendon't.' The high-profile names attached to SEGA's games – from *Michael Jackson's Moonwalker* to *James 'Buster' Douglas Knockout Boxing* – also turned heads.

But SEGA president and CEO Hayao Nakayama was unhappy with the stateside results, as American sales were moving slower than anticipated.

Tom Kalinske, previously of Mattel, was brought in to oversee North America and Europe. He argued that *Sonic the Hedgehog*, not the ageing *Altered Beast*, should be bundled with new consoles in his territories, and he got his way.

It was a masterstroke. By January 1992, SEGA controlled the American console market, knocking Nintendo from the top spot, where it had been ever since the NES launched in 1985. The Genesis outsold the Super Nintendo in the US for four straight years. It had more games and cheaper hardware, and the marketing *had* made it more desirable – less a kid's toy, more a lifestyle product.

In Europe, marketing for the Mega Drive's September 1990 debut was aimed at tempting gamers away from popular home computers. That had also been a dud. It was a price drop in 1991, plus the inclusion of *Sonic the Hedgehog* as the pack-in game, that really made the Mega Drive in Europe. By the time the SNES launched in Europe in 1992, it had a lot of ground to make up – and in many countries, it never did.

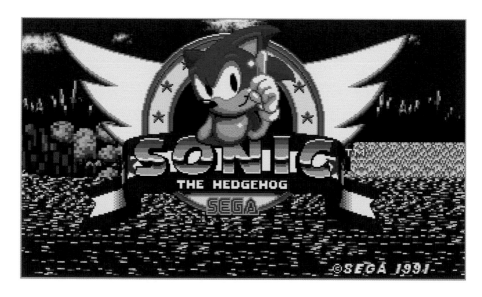

SONIC THE HEDGEHOG

Where Nintendo had Mario as a mascot, SEGA had nothing. They'd tried Alex Kidd, but he'd flopped. In 1989, in the wake of *Super Mario Bros. 3*, SEGA started a company-wide search for a character that could lead a new action title, and ultimately become the friendly, cartoon face of SEGA to gamers around the world.

Around two hundred entries were put forward, with one in particular head and shoulders – and ears – above the rest. It started with Naoto Ohshima drawing a blue rabbit. Ohshima was paired up with programmer Yuji Naka, and they came up with a game for the rabbit – a fast platformer that made full use of the Mega Drive's power to deliver buttery-smooth visuals. One of the character's tricks was rolling. The duo developed that into an attack.

Ohshima was an artist, and had books full of sketches. He pulled one and found a doodle he'd called 'Mr. Needlemouse', a hedgehog with

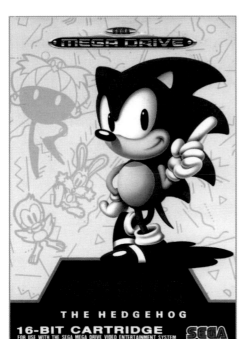

pointy shoes at the end of long legs. The rabbit evolved into a hedgehog, wearing white gloves and socks, his body coloured dark blue to match the SEGA logo.

With the help of designer Hirokazu Yasuhara, game stages were developed to build momentum and allow the hedgehog to reach speeds that Mario never could. There were springs here, loop-the-loops there; vivid greens contrasted with crystal blues; and everything popped from the screen. An enemy was created – Dr. Ivo Robotnik, aka Dr. Eggman, a villain obsessed with technology (whereas the game's

hero loved the natural world). Finally, the hedgehog acquired a name. SEGA had its mascot, and *Sonic the Hedgehog* was ready for the world.

Released in June 1991, *Sonic the Hedgehog* was a massive shot in the arm for the Mega Drive in America and Europe, helping it not just to compete with the SNES, but to thrash it: some 22 million copies of the game were sold, leading to several sequels, and the original Sonic has been widely ported to other systems since its debut. The appeal of Sonic the character set a widespread trend of anthropomorphized platformer protagonists such as Earthworm Jim and Crash Bandicoot, and his oddly proportioned footprint is still felt in games today.

STREETS OF RAGE 2

The Mega Drive's best brawler, SEGA's own *Streets of Rage 2 (Bare Knuckle II* in Japan), followed the arcade beat 'em up formula established by games like Capcom's *Final Fight* and Technōs' *Double Dragon* – walk from left to right, batter foes and face off against an end-of-level boss. Rinse and repeat for a set number of stages.

The first *Streets of Rage*, released in 1991, was a generic but entertaining game of fisticuffs. The next year's sequel blew it away with bigger and bolder visuals, a cornucopia of bad guys to punch and a terrific co-op mode.

But the true jewel in the game's crown was its music, composed primarily by Yuzo Koshiro, whose studio, Ancient, developed the 8-bit *Sonic the Hedgehog*. A simply scintillating collection of pulsating techno and house beats, the soundtrack to *Streets of Rage 2* is one of gaming's greatest, and has been sampled by contemporary artists including Childish Gambino and Die Antwoord. A phenomenal fourth official Streets of Rage game was released in 2020, earning exceptional reviews and featuring another brilliant soundtrack.

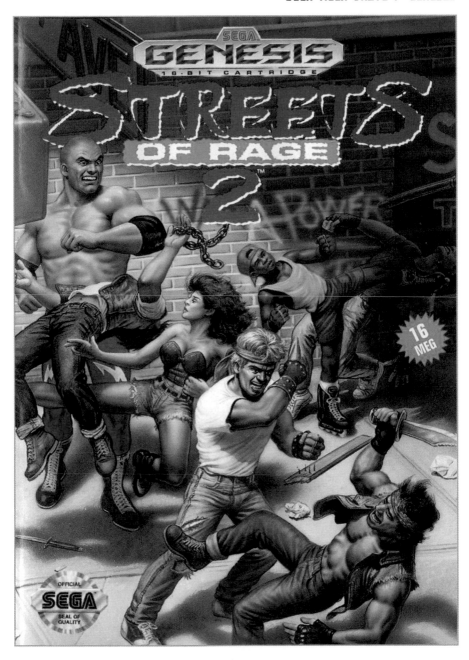

1 SONIC THE HEDGEHOG 2
Released: 1992
Genre: 2D platformer
Any good? Amazing – it may be the definitive 2D *Sonic*.

2 SONIC THE HEDGEHOG CD
Released: 1993 (for the SEGA Mega CD add-on)
Genre: 2D platformer
Any good? Sure is, and worth owning for the incredible (Japanese) soundtrack alone.

3 SONIC THE HEDGEHOG SPINBALL
Released: 1993
Genre: Pinball
Any good? It's distractingly slow, but if you like Sonic and pinball, this is for you.

4 DR. ROBOTNIK'S MEAN BEAN MACHINE
Released: 1993
Genre: Puzzle
Any good? It's a rebranded version of *Puyo Puyo*, a very decent puzzler, so yes.

5 SONIC THE HEDGEHOG 3
Released: 1994
Genre: 2D platformer
Any good? Ace, but it's not quite *Sonic 2* levels of ace.

6 SONIC & KNUCKLES
Released: 1994
Genre: 2D platformer
Any good? Big time, and combining it with *Sonic 3*, via the cartridge's 'lock-on' port, makes it even better.

7 SONIC 3D BLAST
Released: 1996
Genre: Isometric platformer
Any good? Also known as *Sonic 3D: Flickies' Island*, the perspective of this one makes it frustrating to play, and it's one to avoid.

MORTAL KOMBAT

When arcade fighter *Mortal Kombat,* famed for its gruesome end-of-battle fatalities – ranging from beheadings to impalements, via some deadly flambéing – came to home consoles in 1993, the Mega Drive was the system to play it on.

Yes, you could take command of Johnny Cage, Kano, Sub-Zero and the rest of the cast on the Super Nintendo, but that port had one major shortcoming for kids after some visceral thrills: all the blood and guts had been censored out. On SEGA's console, however, there was an easy-to-remember cheat code – ABACABB – which unlocked all the freely gushing gore.

Later, the Mega CD version of the game did away entirely with the need for a cheat code – which meant it got slapped with an adults-only rating. The gore of *Mortal Kombat* attracted controversy, and its content would lead to the creation in the US of the Entertainment Software Rating Board (ESRB), which to this day provides guidelines on a game's age suitability.

EA SPORTS

SEGA launched the Genesis in the US with a raft of sports titles – but it was Electronic Arts' games for the console, collected under the EA Sports umbrella, that really struck a chord with players. EA Sports produced several series, covering ice hockey (NHL), American football (NFL), golf (PGA Tour) and association football (FIFA), with annual entries in each that sold by the skip-load.

Trip Hawkins, EA's founder, told *Retro Gamer* in 2018: 'The Mega Drive was perfect for EA Sports.' And the company certainly didn't hesitate in proving that, with games like *John Madden Football* (1988) and *NHL Hockey/EA Hockey* (1991) taking American sports international, selling

millions worldwide. Then in 1993, *FIFA International Soccer* became a bestseller, kick-starting a series that still tops charts with each yearly iteration.

Suffice to say, if you've never heard the words, 'EA Sports: It's in the game!', chances are you've not played a sports game for the past twenty-five years.

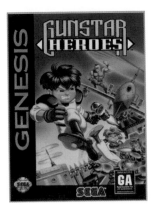

GUNSTAR HEROES

The debut game by Tokyo-based Treasure, *Gunstar Heroes* is a gold-standard run-and-gunner that maintains its essential status to this day, long after its 1993 release as a Mega Drive exclusive.

Casting the player as one of two Gunstars (co-op play involved both protagonists, called simply Red and Blue, taking on enemies together), *Gunstar Heroes* won widespread critical acclaim for its electric action, necessitating lightning-fast responses to overcome an almost overwhelming onslaught of opposition forces. Papaya Dance and Melon Bread might've sounded amusing on paper, but beating these bosses required sharp skills.

It might not have done the numbers of other titles on these pages, but *Gunstar Heroes* is a classic of its genre – one that you need to play if you love SEGA's most successful console.

ECCO THE DOLPHIN

Developed by Hungarian studio Novotrade International, *Ecco the Dolphin* was a bizarre elevator pitch of a game. In it, the player controls a bottlenose dolphin whose family is abducted by aliens and who must travel to both Atlantis and 55 million years into the past to find the power to defeat the extraterrestrials.

Inspired by designer Ed Annunziata's love of nature, prog rock (the last level is named after a Pink Floyd song), and counterculture physician John C. Lilly, *Ecco the Dolphin* is one of the oddest games to have graced SEGA's 16-bit console. Weirder still, it's one of the best. *Ecco* was a big hit for SEGA, spawning a franchise of titles.

DISNEY'S ALADDIN

Disney's 1992 movie *Aladdin* got two 16-bit adaptations, with Capcom taking charge of the SNES game and Virgin Games working on the Mega Drive version.

SEGA's 1993 release stole the spotlight, showcasing fluid animation straight out of the film (Virgin worked with Disney animators), fun platforming gameplay with plenty of unexpected twists – including a journey into the Magic Lamp itself, and bonus stages where the player controls Aladdin's monkey

companion, Abu – and music based on the film's award-winning score. Critical acclaim duly followed, and *Disney's Aladdin* became the third highest-selling game on the Mega Drive, with only *Sonic* and *Sonic 2* surpassing it.

NBA JAM

Originally a Midway Games-produced arcade hit, *NBA Jam* was just as brilliant when played at home on the Mega Drive or SNES.

Best experienced when played with a friend in fierce one-on-one competition, two playable stars per side, it absolutely perfected its gameplay, distilling basketball to a breathless back and forth of epic three-pointers and exaggerated, backboard-smashing dunks. It made the phrases 'He's on fire' and 'Boom shakalaka' commonplace in school playgrounds, regardless of whether or not the kids were actually playing basketball.

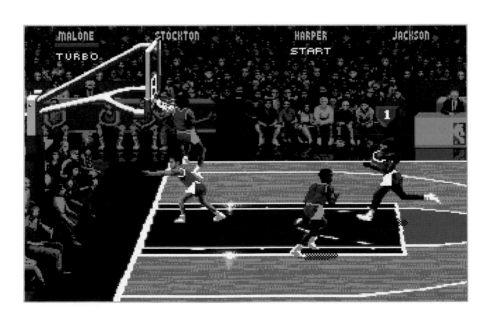

TOO MANY EXTRAS

There was a host of *stuff* you could plug into your Mega Drive, to make it more (or less, weirdly) than what it was before. Here's a small selection of the best and worst.

POWER BASE CONVERTER
What was it? An adapter that let you play Master System games on your Mega Drive. **Useful?** If you had a bunch of Master System games lying around, sure.

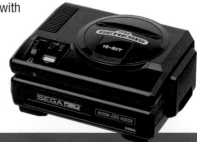

MENACER
What was it? A light gun, in the same vein as the Master System's Light Phaser, only fairly unwieldy due to its weird design. **Useful?** Since it didn't work with Konami's Mega CD masterpiece *Snatcher* – a *Blade Runner*-inspired cyberpunk adventure from celebrated designer Hideo Kojima (before he found global fame with *Metal Gear Solid*) – nope.

MEGA CD/SEGA CD
What was it? A CD-ROM peripheral that slotted beneath the Mega Drive and had its own library of games, some with dodgy, full-motion video clips. **Useful?** While a bit of a flop, the Mega CD had enough excellent games – think *Snatcher*, *Sonic CD* and *Thunderhawk* – to make it a worthwhile add-on.

32X

What was it? A mushroom-shaped lump that sat on top of the Mega Drive like the Power Base Converter and turned it into a 32-bit console with a small range of exclusive games.

Useful? A tragic stopgap between the Mega Drive and SEGA's 32-bit console proper, the Saturn, the 32X had barely any worthwhile games, with stock eventually sold off at rock-bottom prices in the US.

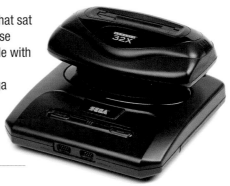

ACTIVATOR

What was it? A plastic octagon placed on the floor that the player stepped inside of, each of its eight sides emitting infrared beams upwards; by breaking a beam, the player would point the on-screen avatar in a direction or trigger the A, B or C button.

Useful? Really, really, really no use, whatsoever.

7 SUPER NINTENDO

WINNING AT HOME, LOSING AWAY

With the Famicom dominant in Japan, Nintendo was confident heading into the launch of its 16-bit Super Famicom (below). And the company's faith in its domestic market was rewarded: the first batch of consoles, released in November 1990, sold out within hours. It was so in-demand that Nintendo had to monitor deliveries to avoid theft by local Yakuza gangs.

Exported as the Super Nintendo (SNES) (right), Nintendo's console was released in North America in summer 1991, and in Europe and Australia in 1992. In the US it slowly gained ground on SEGA's Genesis, eventually overtaking it in sales – albeit *just*, with 23.3 million compared to 22.4 million by the end of the systems' lifetimes. In the UK and other parts of Europe, however, it was SEGA that triumphed.

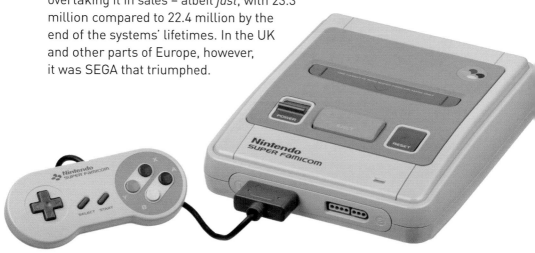

SEGA and Nintendo traded blows throughout the 16-bit era, both coming out with strong exclusive games and a wealth of high-quality releases from developers like Capcom, Electronic Arts, Konami and Square. In the end, the SNES won in terms of total global sales, with just over 49 million units sold compared to the Mega Drive's 29 to 40 million (depending on what sources you look at).

And it's the SNES that, arguably, is considered the better console today by those who didn't take a side in the 1990s. It was voted the number one game system of all time by readers of *Retro Gamer* in 2018; and the release of a mini SNES in 2017, the Super NES Classic Edition, shifted in excess of 5 million units in six months. In 2019, several SNES (and NES) games were added to the Switch Online subscription service, making them playable on Nintendo's newest console. Clearly, the love for all things Super Nintendo hasn't faded since its unveiling.

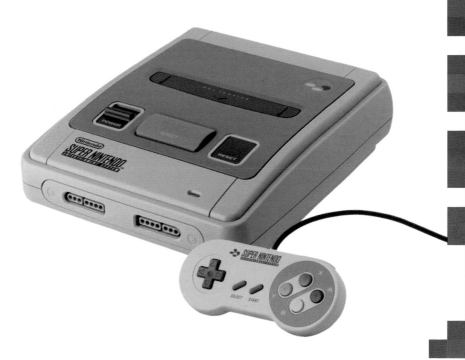

NINTENDO'S YAKUZA HISTORY

While Nintendo had to be vigilant to ensure SNES shipments did not fall into criminal hands, the company's early success actually owes a lot to the Yakuza.

Back in 1889, when Nintendo was founded, the *Hanafuda*, or 'flower cards', it produced were popular in the gambling dens run by the Yakuza. The best players in these *Hanafuda* parlours would regularly demand new cards for each game. Nintendo made a healthy turnover from the shady shenanigans of criminal socializing.

So the next time you see Mario or Link, pause for a second and give thanks to some very bad people indeed for helping bring them into existence.

SUPER MARIO WORLD

Developers at Nintendo had been keen for Mario to ride on the back of a dinosaur for several years. Some claim the desire for a dino was inspired by the NES game *Excitebike* – although *Super Mario World*'s director Takashi Tezuka says the goal was to get Mario to mount a horse.

Regardless, this SNES launch title saw Nintendo's mascot gain a curiously shelled steed, Yoshi. (Said shell, a seat for Mario, stems from early designs depicting Yoshi as a type of Koopa, a turtle-like foe in the series.) The biggest selling SNES game, *Super Mario World* is memorable for much more than its friendly dinosaur: it was a superb evolution of the platforming formula laid down by previous *Super Mario* titles.

New abilities, including a flight-enabling cape, and eye-popping art made possible by the processing power of the SNES, combined with the introduction of Yoshi, really made *Super Mario World* stand apart from its

predecessors. Excitingly fresh but comfortably familiar, it was the perfect introduction to Nintendo's 16-bit console.

A 2017 interview on the official Nintendo website revealed something that *Super Mario World* messed up, however. The game's artist Shigefumi Hino confessed: 'Bowser had the wrong colour! His hide is green, when it should have been orange.' Even seemingly perfect projects can have a blemish or two, then.

F-ZERO

Another SNES launch title, *F-Zero* was a stunningly swift sci-fi racing game that showed off its hardware's Mode 7 graphics. While not truly 3D, this mode gives an impression of depth that older racing games, like SEGA's *Out Run*, couldn't match.

A graphical tour de force, Mode 7 would be used in a number of SNES titles, such as *Super Mario Kart*, *Super Castlevania IV* and Square's superlative Japanese RPGs *Secret of Mana* and *Chrono Trigger*. *F-Zero*, while not having a two-player mode, was critically acclaimed and

received a number of sequels. Its de facto mascot, Captain Falcon, went on to be a mainstay of *Super Smash Bros.*, Nintendo's cross-franchise fighter series.

THE LEGEND OF ZELDA: A LINK TO THE PAST

Released in 1991 to massive sales and critical acclaim, *A Link to the Past* set a number of precedents that the classic Zelda series has maintained to date. It introduced the concept of there being a parallel world to Hyrule; and that the protagonist, Link, will usually need the Master Sword to vanquish whatever evil is bothering the land.

The story of *A Link to the Past* was devised to create a bond between Link and the player: 'We thought players would form an emotional connection,' director Takashi Tezuka told *Retro Gamer* in 2017. And they did, as the

diminutive hero journeys from his humble beginnings to realize his destiny as the 'Hero of Time'.

Tezuka also reflected on the game's classic status by commenting that such praise 'drives us to create new games that will surpass this acclaim'. Few *Zeldas* have been better than this one, however, and with its crisp visuals and compelling narrative – acting as a prequel to the original *Zelda* game – *A Link to the Past* is just as magical to play today as it was at release.

DONKEY KONG COUNTRY

Donkey Kong Country was the first game in its series to not be produced or directed by the character creator Shigeru Miyamoto. Yet the ape's new masters, British studio Rare, delivered one of the SNES's most popular platformers, its striking visuals the result of experiments with 3D Silicon Graphics.

The game wasn't positively received by everyone, however. Miyamoto was widely reported to be unhappy with its pre-rendered graphics and 'mediocre gameplay', and set out to make *Super Mario World*'s sequel, 1995's *Yoshi's Island*, a visual extravaganza that would put *Country* in the shade. The games certainly have dramatically different aesthetics, but the truth is that both stand proudly as two of the SNES's very best.

SUPER MARIO KART

The first and only *Mario Kart* entry to lead with the 'Super' prefix – trading on the *Super Mario* platformers' recognition – this gleeful racer, full of drivers from Nintendo history, was released in 1992 and became the SNES's fourth bestselling game. It introduced many of the subsequent series' common traits – on-track items like green and red shells, cup competitions like Mushroom and Flower, and speed settings graded by 'cc'.

Super Mario Kart also features a battle mode, where players swap circuit racing for arena combat, the objective being to pop your opponents' balloons before yours go bang.

When *Mario Kart 8* released for Wii U in 2014, there was widespread disappointment that battles could only play out on standard tracks. Such was the negative response that Nintendo brought back battle courses proper for 2017's *Mario Kart 8 Deluxe* on Switch, reconnecting the series' greatest entry thus far with its debut.

STAR FOX

1993's *Star Fox* – known as *Starwing* in Europe – was another major SNES title to push its parent hardware in new ways. The game's cartridge featured a Super FX chip, making polygon graphics possible before they became commonplace in the 32-bit era.

Underneath the impressive visuals, *Star Fox* was a routine shoot 'em up,

THE MANY JOBS OF MARIO

Nintendo's mascot is known as a plumber, the profession given to him in 1983's *Mario Bros.* game. But he's held down a number of other gigs. Here are just a few of them.

CARPENTER
As seen in: *Donkey Kong*
Tool of the trade: Mario can pick up a hammer to destroy oncoming barrels.

DOCTOR
As seen in: *Dr. Mario*
Tool of the trade: Mario wears a stethoscope around his neck – how else would you know he's a medical professional?

TENNIS UMPIRE
As seen in: *Tennis*
Tool of the trade: Mario sits up there on that high chair, beside the net, leaving players in no doubt as to who's in charge.

BOXING REFEREE
As seen in: *Punch-Out!!*
Tool of the trade: Mario wears a bow tie, identifying him as an official, not a fighter.

ARTIST
As seen in: *Mario Paint*
Tool of the trade: Mario's got a neat collection of paintbrushes and canvases, sure to be useful when accepting commissions from around the Mushroom Kingdom.

on-rails game that moved you forwards on a preset path – plenty of fun, but nothing to surprise players of prior sci-fi blasters like *Space Harrier*.

But *Star Fox* had something that other space-set shooters didn't – a cast worth caring about. The characters – Fox McCloud, Peppy Hare, Slippy Toad and Falco Lombardi – have subsequently appeared not only in *Star Fox* sequels but in other Nintendo series, including *Super Smash Bros.*

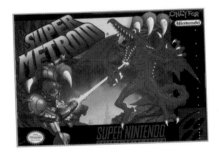

SUPER METROID

The most critically acclaimed SNES title ever, according to GameRankings.com (with a score of 96.55%), *Super Metroid* was released in 1994 and immediately set an incredible high for its series. The player still controls Samus Aran, as they did on the NES original and its Game Boy sequel, *Return of Samus*. But now Metroid earns its reputation for engrossing, explorative gameplay, created through environment-unlocking abilities coupled with an uncommonly creepy atmosphere.

With a handy map auto-generating as Samus explores the planet of Zebes, it's never a chore to track back to previously visited locations; while the surprises that she experiences – whether the return of the villainous Space Pirates or the evolution of the now-enormous jellyfish-like Metroid

from *Return of Samus* – are shared by awestruck players.

A multi-award-winner, *Super Metroid* seemed like such a success that Nintendo didn't know where to go next – a whopping eight years passed before the series' next games, 2002's *Metroid Prime* for the GameCube and *Metroid Fusion* for Game Boy Advance. Samus was warmly welcomed back, her returns (including 2021's Switch-exclusive *Metroid Dread*) almost as celebrated as this essential SNES adventure – but for *Metroid* newcomers, *Super* is the one to start with.

SQUARE'S SENSATIONAL JRPGS

Role-playing games were popular before the 16-bit era, but some of the greatest Japanese ones – known as JRPGs, for short – made their debut on the Super Nintendo. Foremost among these is a pair of titles developed by Square (now Square Enix).

1993's action-orientated JRPG *Secret of Mana* (*Seiken Densetsu 2* in Japan) took a few cues from *Zelda*, with its story of a young boy and his magical sword, and used similar real-time combat. But gorgeous art and beautiful music, as well as a two-player co-op option (there's nothing like playing through this fantastical adventure with a friend), gave it a strong identity all its own.

Then there's 1995's *Chrono Trigger*, perhaps Square's greatest achievement. With a plot that time-travelled from the destruction of the world to prehistory, a variety of potential endings and six memorable controllable characters (who could combine powers in *Final*

Fantasy-like turn-based battles, creating awesome new attacks), it was an instant hit in Japan, selling 2 million copies in just two months. An English-language version was released in North America, but it never officially came out in Europe.

Chrono Trigger regularly appears in lists ranking the best games of all time. In 2002 it was fourth on IGN's list, moving up to second in 2008, and in 2014, Gamesradar.com named it the second best SNES game ever. It's the third highest-rated SNES game, with a score of 95.64%, on GameRankings.com. Basically, it's an indispensable entry in the console's catalogue, and it's easily playable today thanks to an excellent Nintendo DS port.

KILLER INSTINCT

By the mid-1990s, the SNES (and the Mega Drive, for that matter) were facing stiff competition from Sony's PlayStation. But Rare, which had already pushed the SNES's graphics with *Donkey Kong Country*, released another remarkable looker in 1995 with the home port of their arcade fighter *Killer Instinct*.

Taking a more combo-focused approach than *Street Fighter II* or *Mortal Kombat*, *Killer Instinct* was hilariously over the top – its characters include a human-velociraptor hybrid and a werewolf. But it's mechanically tight, and found many fans in the fighting-game community.

STREET FIGHTER II

The 1990s' definitive one-on-one arcade fighter came to the Super Nintendo before any other home console. But while it required a large 16-megabit cartridge to even fit onto the SNES, Capcom's seminal title still needed to be streamlined for its conversion. Certain characters had attacks removed, voice samples were cut and the arcade games' animated backgrounds were simplified.

Nevertheless, *Street Fighter II* on SNES was a revelation. A lot had been written about the arcade game, and hype for 1992's SNES port grew to fever

pitch. Not even an asking price of (at least) $69.99 in the US, and £60 to £70 in the UK, could quell anticipation, and the game's total sales of 6.3 million units make it the fifth bestselling SNES game of all time. With its six-button controller mirroring the arcade cabinet's three punches and three kicks, Nintendo's system was *Street Fighter II*'s perfect play-at-home partner.

The game didn't stay exclusive to the SNES – updated versions came out for SEGA's Mega Drive, and a wealth of contemporaneous platforms received stripped-back takes on the original (avoid the Amiga version). Overall, the entire *Street Fighter II* range has made Capcom over $10 billion, but no single release has ever equalled the excitement of the first SNES game.

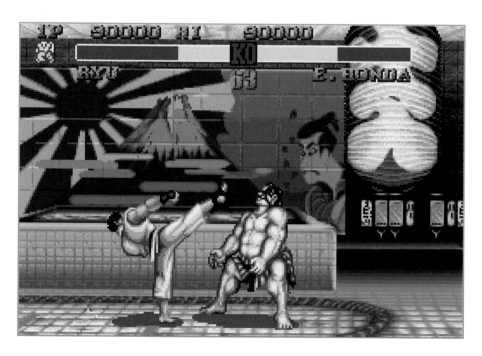

THE AMERICAN SNES AND A BAG OF BREAD

Just as the Famicom was redesigned for sale outside of Japan, the Super Famicom/SNES was given a new form for its American release. But what made the US want a model of its own?

With a squared body and a palette change, and swapping multicoloured buttons for shades of purple, the American console really made a statement – which some loved and others hated. But the reason for the change was simple: Nintendo of America didn't think the Japanese model would look good with an add-on peripheral, such as a proprietary disc drive, placed beneath it.

Nintendo of America's Lance Barr, when interviewed in 2006, said: 'For the US, I felt that it was too soft and had no edge. We were always looking at future modular components, so you had to design with the idea of stacking on top of [them]. I thought the Super Famicom didn't look good when stacked, and even by itself, it had a kind of "bag of bread" look.' Crumbs.

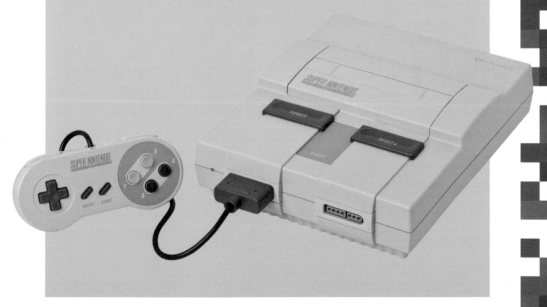

THE ORIGINAL WORLD WARRIORS OF STREET FIGHTER II

BLANKA
Country of origin: Brazil
Fighting style: Self-taught, ultra-violent animalistic assaults (and he sometimes emits electricity, as one does)

CHUN-LI
Country of origin: China
Fighting style: A combination of wushu, karate, judo, taekwondo and capoeira (beware her lightning-fast high kicks)

DHALSIM
Country of origin: India
Fighting style: A unique mix of stretchy limbs and fiery yoga techniques (take cover if he takes a deep breath, as things are about to heat up)

GUILE
Country of origin: US
Fighting style: Taekwondo blended with some close-quarters wrestling moves (try not to gawp at his haircut for too long)

E. HONDA
Country of origin: Japan
Fighting style: Sumo, with just a dash of surprisingly swift flying headbutts (do not be suckered by his suggestion of a nice cuddle)

KEN MASTERS
Country of origin: US
Fighting style: Shotokan karate with a hurricane kick or two beyond the conventional (and mind those flaming uppercuts)

RYU
Country of origin: Japan
Fighting style: As a training partner of Ken, Ryu favours the same kind of karate (but do be wary of his penchant for summoning fireballs)

ZANGIEF
Country of origin: Russia
Fighting style: Hand-to-hand SAMBO and pro wrestling techniques are the big man's go-to moves (so time spent pressed against his perfectly sculpted chest hair is unlikely to end well)

The World Warrior

© CAPCOM 1991, 1992
© CAPCOM U.S.A., INC. 1991, 1992

PRESS

PLAYER SELECT

1P
BLANKA

TV TIE-INS

If something was big on TV in the 1980s and 1990s, there was a good chance it'd get a video-game adaptation (or several). Here is a selection of well-known names from the small screen that made the jump to computers and consoles.

THE SIMPSONS
Games: 27 and rising
Pick of the bunch: In the vein of SEGA's *Golden Axe* and Konami's own *Turtles*, a 1991 Konami arcade game simply titled *The Simpsons* was a frenetic four-player scrolling beat

'em up that received ports to Commodore 64 and MS-DOS. The very first game to be based on Matt Groening's show, *Bart vs. the Space Mutants*, was distinctly average, but its wide availability, on everything from the NES to the Game Gear, made it a favourite.

STAR TREK
Games: Over 30
Pick of the bunch: The first *Star Trek*-inspired (text-only) video game dates back to 1971. For something more evergreen, though, try 1992's *Star Trek: 25th Anniversary* for PC, a point-and-click adventure featuring the show's original cast that plays out over 7 'episodes'. The CD-ROM version of the game even features voice-over work from the TV actors.

THUNDERCATS

Games: Just 2

Pick of the bunch: Discounting 2012's terrible Nintendo DS game *ThunderCats* on account of it not really being old enough, we're left with 1987's *The Lost Eye of Thundera*, which

came out for Amiga, Atari ST, ZX Spectrum and more. A side-scrolling action game, it casts the player as Lion-O on a quest to recover – you guessed it – the Eye of Thundera. It's … not very good. At all. Sorry, *ThunderCats* fans.

SOUTH PARK

Games: 9

Pick of the bunch: Games based on *South Park* started coming out in 1998, the year after the show debuted. The first, for PlayStation and Nintendo 64, was a pitiful first-person shooter that captured none of its source material's humour. It wasn't until 2014 that a recommended *South Park* game arrived, the Obsidian-developed RPG *The Stick of Truth* – not exactly retro, that one.

DUCKTALES
Games: 5, including a remaster
Pick of the bunch: The go-to for Scrooge McDuck fans, Capcom's 1989 adaptation of the Disney series for the NES and Game Boy was a platformer with levels playable in any order. Remastered in 2013, the original 8-bit version of *DuckTales* was rereleased in 2017 as part of Capcom's *The Disney Afternoon Collection*, and it's easy to find today for Xbox One, PlayStation 4 and PC.

ALF
Games: 6
Pick of the bunch: With four games based on the hit US sitcom *ALF* being purely educational offerings, that leaves just 1987's *Pac-Man*-like *ALF: The First Adventure* for Atari ST, C64 and more, and 1989's SEGA Master System-exclusive platformer *ALF*. Both are awful, but SEGA's game at least lets you, as ALF, whack bats with a salami.

MIGHTY MORPHIN POWER RANGERS
Games: 23
Pick of the bunch: There are some real stinkers here, like the *F-Zero*-aping *Power Rangers Zeo: Battle Racers* for the SNES. The same console received what is probably

the best *Power Rangers*-inspired game, though, with 1995's tie-in title *Mighty Morphin Power Rangers: The Movie*. A co-op beat 'em up in the vein of *Final Fight* and *Streets of Rage*, it was good enough to appeal to gamers who didn't care for the Rangers themselves.

DOCTOR WHO
Games: At least 13
Pick of the bunch: The first game to feature the BBC's time-travelling alien, appropriately titled *The First Adventure*, came out in 1983. But it was 1992's *Dalek Attack* where the Doctor really peaked. Available for computers including the Commodore Amiga

and Atari ST, this action-packed platformer allowed players to choose from the Fourth, Fifth or Seventh Doctor, and featured a decent version of the show's theme tune too. A second player could join in, assuming the role of the Seventh Doctor's companion Ace or a UNIT soldier.

HE-MAN AND THE MASTERS OF THE UNIVERSE

Games: 9

Pick of the bunch: *Masters of the Universe: Super Adventure* was a 1986 text-based role-player that tested your brain rather than your brawn. Gremlin's C64 and Spectrum game, based more on the 1987 *Masters of the Universe* movie spin-off than the animated TV series, offered a very different experience, with top-down shooting sections broken up by side-on combat sequences. It's an acquired taste, but probably the best of the bunch.

THE X-FILES

Games: 4

Pick of the bunch: *The X-Files Game* – released in 1998 for Windows and Mac and in 1999 for PlayStation – is the sole title based on the exploits of agents Mulder and Scully to comfortably fall into our retro timeframe. (2004's *Resist or Serve* for the PS2 is pushing it.) *The X-Files Game* is an interactive movie, set concurrently with the show's

third series. David Duchovny and Gillian Anderson make cameos, but you play as a young agent by the name of Craig Willmore, who has to get to the bottom of a very *Invasion of the Body Snatchers*-like conspiracy.

THE TRANSFORMERS

Games: 31

Pick of the bunch: Today's players have been spoiled by High Moon's *War for Cybertron* and PlatinumGames' *Devastation* – excellent action titles featuring the shape-shifting robots. Older gamers had no such luck. The first game for C64 and Spectrum, released in 1985, was a rotten shooter; and 1986's *The Battle to Save the Earth* was equally miserable, despite design work from *Pitfall!* creator David Crane. It wasn't until 2004's *Transformers* for the PlayStation 2, based on the *Transformers: Armada* line, that fans of the 'bots finally had a worthy tie-in.

8 AMIGA, ST AND PC

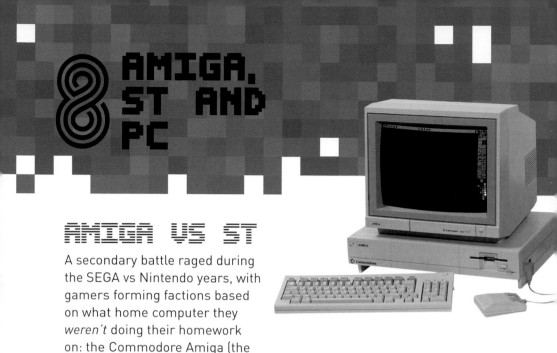

AMIGA VS ST

A secondary battle raged during the SEGA vs Nintendo years, with gamers forming factions based on what home computer they *weren't* doing their homework on: the Commodore Amiga (the C64's successor) or the Atari ST (opposite), part of its makers' 8-bit line.

Unlike the rivalry between the wildly different ZX Spectrum and Commodore 64, the Amiga and ST were incredibly alike. Both contained 16-bit Motorola 68000 processors, meaning they could display game graphics largely on a par with the Mega Drive (which also used the 68000) and Super Nintendo; and both used a keyboard, mouse inputs and the same 3.5-inch floppy discs. If a new game was on the Amiga, it was usually on the ST too.

The Amiga wasn't just one computer; it was a range, which Commodore had bought from Amiga Corporation in 1984, rolling out under Commodore with July 1985's Amiga 1000 (above). Initially retailing at around £1,500 in the UK and introduced at $1,250 in the US (the equivalent of $3,000 in 2019), the A1000 was beyond the means of many. The ST, while costing less, still retailed for the not insignificant sum of $799 for a basic monochrome model.

It was new models and price cuts that saw these computers take off. Commodore's Amiga 500 (left)

came out in 1987 for £499/$699, and Atari reduced the ST's price tag accordingly. The A500 had a huge impact on the home computer market, proving especially popular in Europe, and Commodore ran marketing that SEGA likely approved of, with one advert proclaiming: 'New Amiga 500. Now other home computers are just toys.'

One fun fact about this home computer competition is that the Amiga was actually designed by two ex-Atari employees, Jay Miner and Larry Kaplan (the latter also co-founded Activision) before Commodore bought out the Amiga Corporation. Another is that the programming language for the Amiga range, AmigaBASIC, was made by Microsoft – long before the company developed its Windows operating systems, Internet Explorer and all the rest of it.

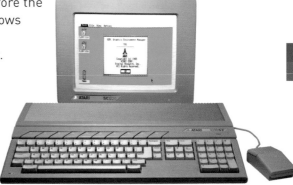

PCS AND MS-DOS

If you didn't own an Amiga or an Atari in the 1980s or '90s, perhaps your home computer of choice was a PC running MS-DOS, an operating system developed by Microsoft and used between 1981 and 2000 (ultimately succeeded by Windows). It was through MS-DOS – Microsoft Disk Operating System – that many amazing PC games arrived in players' hands, from *Prince of Persia* to *DOOM*.

MS-DOS was a key product in Microsoft's history; its success, more so than that of AmigaBASIC or anything else it had produced to that point, allowed the company to grow into the behemoth it is today.

PRINCE OF PERSIA

Originally released on the Apple II in 1989, Jordan Mechner's *Prince of Persia* was widely ported in 1990, with versions coming to the Amiga, the ST and MS-DOS.

The progenitor of a small category of games known as cinematic platformers – French studio Delphine Software would add to this niche with *Another World* and *Flashback* – *Prince of Persia* was notable for its amazingly lifelike animation, achieved through rotoscoping (drawing over photos of a person moving). It also featured some gory deaths, which made falling victim to its traps rather more appealing to certain gamers.

SIMCITY

1989's *SimCity*, designed by Will Wright, charged players with the laying out and maintenance of an entire city. Which doesn't sound thrilling, immediately, but the game's easy interface and range of disasters – including floods, earthquakes and a plane crash – which can strike settlements still finding their feet, propelled it to commercial and critical success, and won it several awards.

First released for Amiga and Macintosh, *SimCity* was ported to 8- and 16-bit systems alike, including the Commodore 64 and Super Nintendo. A number of sequels and Sim-prefixed spin-offs followed in its wake, such as

SimEarth and the incredibly popular series of virtual people (mis)management games, *The Sims*.

LEMMINGS

This may be the definitive puzzle game for the Amiga. Developed by Dundee-based DMA Design – later makers of *Grand Theft Auto* – and published by Psygnosis in 1991, *Lemmings'* cute title characters immediately appealed.

You are supposed to *save* the lemmings from hazards, turning starter drones into 'climbers', 'blockers' and more to get them to the exit, but there was glee, too, in watching the mindless creatures explode, splat and generally fall foul of on-screen nastiness.

Amiga Power magazine named *Lemmings* the second best Amiga game of all time, and it received numerous ports and sequels.

BATMAN: THE MOVIE

Sold with Amiga 500s in the UK in 1989 and 1990 alongside Taito's colourful platformer *The NewZealand Story* and art package *Deluxe Paint II*, the Ocean Software-developed *Batman* was one of the best movie tie-ins of its time.

Featuring five levels based on scenes from 1989's Tim Burton-directed film, ranging from Batmobile racing to 2D platforming, its inclusion as a

pack-in title for new Amiga purchasers saw Commodore shift 186,000 units – the most of any British bundle.

ALIEN BREED

The second game from British studio Team17, 1992's *Alien Breed* was a film licence in everything but an official capacity, lifting inspiration from James Cameron's *Aliens*.

It's a breathless top-down experience – take the locked doors and dangerous enemy swarms of *Gauntlet*; add pulse rifles and a thick atmosphere of dread – and the game's success paved the way for the studio to produce more titles, including 1995's widely acclaimed *Worms*.

SPEEDBALL 2: BRUTAL DELUXE

The Bitmap Brothers presented themselves as the era's most rock 'n' roll developers – and nobody argued with them. The studio produced a string of greats for the Amiga and other platforms – *The Chaos Engine*, *Xenon II: Megablast* and *Gods* to name but three – but *Speedball 2* is the chosen one, here.

A future-set sports game where violence is encouraged in order to win, this 1990 sequel to a less-essential first game was a must-have for Amiga owners. Ostensibly an all-contact version of handball, the actual 'sport' of Speedball was an intoxicating

proposition – and *Speedball 2*'s impeccable presentation, and cries of 'Ice cream!' from the crowd, guaranteed it all-time classic status.

THE SECRET OF MONKEY ISLAND

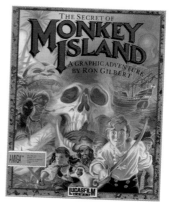

Having pioneered its verbs-ahoy SCUMM engine with 1987's *Maniac Mansion*, Lucasfilm Games put the intuitive point-and-click system to work on more titles, including 1988's *Zak McKracken and the Alien Mindbenders* and 1989's *Indiana Jones and the Last Crusade: The Graphic Adventure*. Then came 1990's *The Secret of*

Monkey Island, perhaps the studio's best-ever adventure.

A pirate-themed, jokes-stuffed, three-part story that takes the player's character, the hapless Guybrush Threepwood, across the Caribbean in pursuit of a ghostly captain and a kidnapped governor, *Monkey Island* is a game where head-scratching moments never gave way to frustration due to its brilliant sense of humour. Both it and its excellent 1991 sequel received special-edition rereleases, with updated visuals and voice-overs, in 2009.

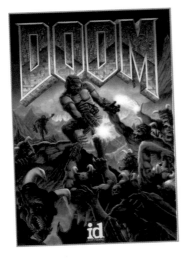

DOOM

Released onto PC in December 1993, *DOOM* was the first-person shooter that really set the genre on the way to the mainstream. With richly detailed environments, a cast of gruesome demons to slaughter and brilliant guns (like an all-time favourite shotgun and the notorious BFG – and no, we're not about to publish what its initials stand for here), its reputation swiftly preceded it.

The work of Dallas-based studio id Software, led by programmers John Romero, Dave Taylor and John Carmack, the horror-meets-sci-fi setting of *DOOM*, combined with its electrifying gameplay, made it a runaway hit. Widely ported, the original *DOOM* is practically ubiquitous across gaming (and non-gaming) hardware, old and new – which is to say, it's been made to run on everything from

digital thermostats to ultrasound machines. And that's before factoring in sequels and the brilliantly received 2016 reboot.

The *DOOM* series has sold millions, but none of that success would have been possible without this first game – a title that shook up the shooter scene. It brought players together like never before through pioneering multiplayer matches and inspired developers the world over to create their own FPS games in its image.

HALF-LIFE

The first game developed by Valve, 1998's *Half-Life* for Windows (and later PlayStation 2) is probably the second most famous PC FPS after *DOOM*. Silent protagonist Gordon Freeman gets caught up in an alien invasion of Earth. He crosses into the dimension of Xen, defeating the alien leader, to bring some measure of normality back to our universe – albeit not too much, as a hugely acclaimed sequel followed in 2004, with fans ravenous for any rumour whatsoever regarding a third game in the series. (Pro-tip: do not hold your breath.)

Half-Life was instantly hailed as one of the best video games ever developed, a verdict that's not changed in the years since. Unlike *DOOM*, it went to town on its story, with an unprecedentedly rich narrative playing out before the player's eyes. In 2013, IGN declared it the greatest FPS of all time, and a turning point in the genre's evolution: 'When you look at the history of

first-person shooters, it breaks down pretty cleanly into pre-*Half-Life* and post-*Half-Life* eras.' The editors concluded that the game was 'the cornerstone of FPS design today'.

MOONSTONE: A HARD DAYS KNIGHT

To play *Moonstone* was to remember it, always. No other game on the Amiga was quite as giddily bloody as Mindscape's medieval adventure of 1991, which set four knights on a race to a Stonehenge-like structure at the centre of the game's map.

Stopping at tombs on the way – necessary for discovering four keys – would see the knights attacked by all manner of nasty monsters; and the knights could clash with each other too, leading to comical beheadings.

Moonstone split critical opinion, but was absolutely one of the most memorable role-players on the Amiga and MS-DOS.

ZOOL

With Mario at Nintendo and Sonic at SEGA, there was demand for a mascot-level character at Commodore. But 1992's *Zool* for the Amiga, despite an extremely positive critical reception, didn't make a star of its heroic 'Ninja of the Nth Dimension'.

Slick and speedy, with delicious visuals, *Zool* looked and played the part. It received ports to consoles and a decent sequel, 1993's *Zool 2*. Yet despite this strong start, that was it for the gremlin-like main character, who never had the charisma of Sonic and Mario.

WARCRAFT: ORCS & HUMANS

This is where it all began for Blizzard's massive *Warcraft* series, which has since encompassed several books and comics, a collectible card game (which became *Hearthstone*) and a big-budget movie adaptation. A fantasy real-time strategy game that really pushed its multiplayer options, 1994's MS-DOS debut *Orcs & Humans* sold enough copies – over 100,000 in its first year – to balance Blizzard's books and set them on their way.

Its sequel, 1995's *Warcraft II: Tides of Darkness*, refined and polished the core gameplay, improved the AI and fleshed out its storyline and supporting lore. It received a host of awards, and sold 2.5 million units by the end of 1998. One of gaming's most famous franchises had truly arrived.

THE ELDER SCROLLS: ARENA

Another massive series that started in the MS-DOS years, the Bethesda-developed *Arena* introduced the continent of Tamriel, the classic *Elder Scrolls* setting.

It doesn't look like much today, next to the stunning landscapes of *The Elder Scrolls V: Skyrim*, but its 3D visuals made an impression in 1994. And the gameworld itself, while less detailed than other titles which came in *Arena*'s wake, actually

surpasses *Skyrim* in scale, covering 2.3 million square miles. There's a caveat to that, though: *Arena* randomly generates its environments, whereas modern *Elder Scrolls* games feature handmade maps.

Celebrated for its story, combat and graphics – and featuring a few of those bugs that Bethesda's become so oddly cherished for (like being able to carry an infinite number of lightweight daggers) – *Arena* became a cult favourite, and opened the door for further exploration of its fantasy world.

CANNON FODDER

By 1993, Sensible Software had plenty of hits to its name. And the British studio's output was extremely varied, mixing the real-time strategy of *Mega-Lo-Mania* and anything-goes experimentation of *Wizkid* with one of the 1990s' finest (association) football games, *Sensible Soccer*. But the gallows humour and precision gameplay of isometric wartime shooter *Cannon Fodder* won instant approval from critics – it received scores of 95, 94 and 93 per cent from *Amiga Format*, *Amiga Power* and *Amiga User International*, respectively.

Cannon Fodder's goriness did raise some questions, however, and its use of a poppy in marketing material upset the Royal British Legion. Its makers were defensive, saying the game conveyed an anti-war message, and it did: the more you played *Cannon Fodder*, and the more troops you lost, the more futile the very idea of war became. The controversy that the game generated, stoked by the tabloid media, was acknowledged by *Amiga Computing* as 'perhaps the best campaign' the game could have hoped for.

AMIGA, BUT WEIRDER

Around 6,000 games were released for the Commodore Amiga, so naturally there were some oddballs among them. Here are three to check out.

SOCCER KID
Released: 1993
What was it? *Soccer Kid* is a platformer where enemies are defeated by booting a size five at them, the objective being to find five pieces of the World Cup, shattered when an alien tried to steal it. It's pretty good, so long as you don't stop to question why you're murdering gymnasts and opera singers with a leather ball.
Other platforms: MS-DOS, Sony PlayStation, Atari Jaguar, Super Nintendo (as *The Adventures of Kid Kleets*)

WEIRD DREAMS
Released: 1989
What was it? The clue's in the name, for this one. It casts the player as Steve, who's trapped inside a nightmare of his own making, full of imagery inspired by Salvador Dalí. It was also a phone-in game on British children's TV show *Motormouth* – players called the programme and controlled Steve via spoken commands – which increased the game's visibility but also amplified how frustrating it was to play.
Other platforms: ST, MS-DOS, Commodore 64

CAPTAIN BLOOD
Released: 1988
What was it? A sci-fi graphic adventure with so-called 3D flying sections, *Captain Blood* is the story of its developer, who's been sucked into his own game. He has to find five of his clones – a task made near-impossible by an impenetrable interface – and kill them, because ... video games.
Other platforms: ST, C64, ZX Spectrum, Amstrad CPC

COMMAND & CONQUER

Debuting on MS-DOS in 1995, Westwood Studios' *Command & Conquer* is a true Hall of Fame-standard release in the real-time strategy genre. Set in an alternative reality where the United Nations battles the militant Brotherhood of Nod, the player must build a base on the game map and collect resources to both develop offensive weapons and strengthen defences. Once suitably supplied, you attack and (hopefully) take down your enemy's encampment. Sounds easy, but *C&C* was a deep game that necessitated careful planning: a strictly disciplined approach to harvesting and construction, with no single step rushed, was essential to amassing the power required for eventual glory.

Command & Conquer raced to 1 million sales before its first anniversary. A number of sequels followed, including 2008's fantastically overacted *Command & Conquer: Red Alert 3* (please, have a look online for *RA3* actor Tim Curry's declaration that he's leaving Earth for 'spaaace', and check your pulse if you don't laugh). And in 2018, *C&C* series publishers Electronic Arts announced the development of a remastered version of the original game to a rapturous reception.

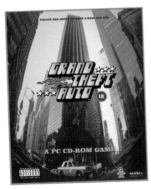

GRAND THEFT AUTO

The fourth highest-grossing video game series of all time began on PC, with the debut *Grand Theft Auto* hitting Windows and MS-DOS in October 1997, before its release for the PlayStation in December of the same year.
While aesthetically very different from the *GTA*s of the HD era, with their multiple

protagonists and realistically rendered cities, this top-down game of cops and robbers from DMA Design (later renamed Rockstar North) features much of the DNA that survives to the present day: car theft, criminal activity, law avoidance and a great degree of player agency and freedom, allowing for ample emergent gameplay hijinks.

CALL OF DUTY

Another major franchise that got its break on PC, the original *Call of Duty*, developed by California studio Infinity Ward, debuted on Windows in October 2003.

Set in multiple locations during the Second World War, with American, British and Russian scenarios, *Call of Duty*'s high-stakes action won acclaim, and ultimately earned it sales of 4.5 million across all formats. The series is still going strong today – since 2005's *Call of Duty 2*, not a single year has passed without a new game.

MORE CONSOLES YOU PROBABLY NEVER PLAYED

1 ATARI JAGUAR
Launched: 1993 **Discontinued:** 1996

Pitch: The 64-bit Jaguar (not actually a 64-bit system, but that was the marketing angle) was Atari's final console to use interchangeable cartridges. Despite being more powerful than the SEGA Mega Drive and SNES, and releasing ahead of the PlayStation, it didn't attract much third-party support and never found a commercial foothold, selling fewer than 250,000 units.

Three to play: *Alien vs. Predator* (1994), *Tempest 2000* (1994), *Rayman* (1995)

2 3DO
Launched: 1993 **Discontinued:** 1996

Pitch: The 3DO wasn't one console, but more a specific set of components that could be assembled and boxed (quite differently) by different manufacturers. Despite a healthy games library of more than 280 titles today, its launch price – a staggering $699 – was its undoing. Sales were rapidly overtaken by the PlayStation and SEGA Saturn, both more powerful and less expensive.

Three to play: *Road Rash* (1994), *Way of the Warrior* (1994), *Immercenary* (1995)

3 NEO GEO AES
Launched: 1990 **Discontinued:** 1997

Pitch: A major player in the arcades with its Multi Video System (MVS) cabinets – which allowed up to six game cartridges to be installed at once – SNK's debut Neo Geo home console was specifically targeted at gamers who had money to burn. Launched in the US at $650, the AES (Advanced Entertainment System) was fully compatible with SNK's arcade cartridges, which retailed for $300. A miniature, arcade cabinet-styled version of the Neo Geo, with forty built-in games, was released in 2018.

Three to play: *Windjammers* (1994), *Samurai Shodown II* (1994), *Metal Slug* (1996)

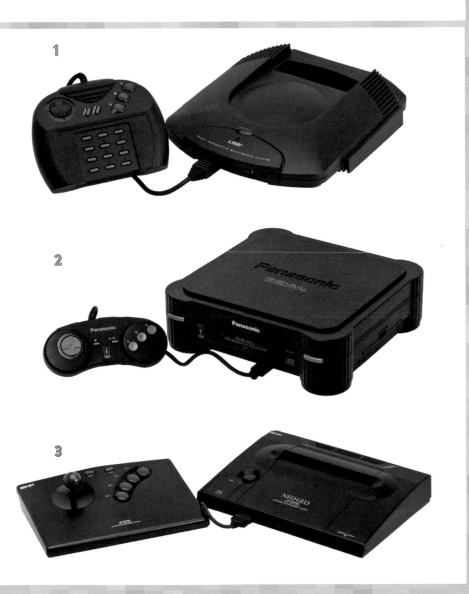

 ### PHILIPS CD-I
Launched: 1991 **Discontinued:** 1998

Pitch: Not strictly a games console, the CD-i (for compact disc interactive) was a multimedia device and home-to-school software and encyclopaedia package. But over 190 games were released for the system too, among them titles in the *Mario* and *Zelda* series never released on Nintendo consoles. Said exclusives, including *Hotel Mario* and *Zelda's Adventure* (the first game in which you actually play as the princess) received the same kind of reception as the CD-i, however: a critical panning.

Three to play: *Burn:Cycle* (1994), *The Apprentice* (1994), *Secret Mission* (1996)

 ### AMIGA CD32
Launched: 1993 **Discontinued:** 1994

Pitch: In the late 1980s, the Commodore 64 was selling well and its makers decided to manufacture a games-only console model of the computer, the C64GS, which came out in 1990. It bombed, but didn't put Commodore off another attempt, and in 1993 they released a CD-ROM console based on specs similar to the Amiga 1200 computer. The first 32-bit console to release in the US and Europe, the CD32 ultimately failed not because of any headaches with its hardware, but due to Commodore entering bankruptcy in 1994. The CD32 had been its make-or-break product, and while it sold solidly, it couldn't make up for past mistakes that left Commodore in the red.

Three to play: *Simon the Sorcerer* (1994), *Ultimate Body Blows* (1994), *Beneath a Steel Sky* (1994)

 ### APPLE BANDAI PIPPIN
Launched: 1996 **Discontinued:** 1997

Pitch: An Apple Macintosh in console form, the Pippin was in some ways a product ahead of its time, with a built-in internet modem and an upgradeable operating system. It wanted to be the machine to keep under your TV, both home computer and games console. But its $599 price in the US put it at a significant disadvantage, and with a lightweight software library, the Pippin – also called the Atmark – failed to make an impression.

Three to play: *Gadget: Intention, Travel & Adventure* (1996), *Super Marathon* (1996), *Racing Days* (1996)

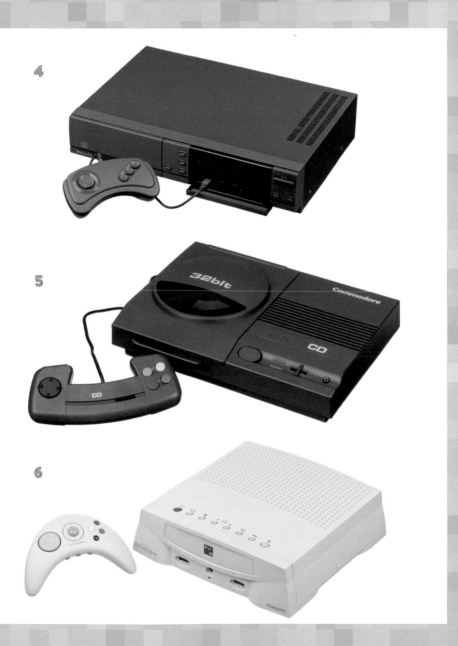

4

5

6

 PC-FX
Launched: 1994 **Discontinued:** 1998
Pitch: The 32-bit successor to the PC Engine, NEC's PC-FX was an interesting, Japan-exclusive console with a miniature desktop-PC look about it. It released around the same time as the Sony PlayStation and SEGA Saturn, but it wasn't set up to process 3D polygons – and it was 3D polygons that would be the dominant graphical style through the 32-bit generation. The console didn't sell well, and its small games library is dominated by adaptations of Japanese anime and dating simulators.
Three to play: *Battle Heat!* (1994), *Chip Chan Kick!* (1996), *Fire Woman Matoigumi* (1996)

 NINTENDO VIRTUAL BOY
Launched: 1995 **Discontinued:** 1996
Pitch: Nintendo got experimental in 1995 with the release of their one and only virtual reality console. Sitting the unit on top of a table, the player peered into an eyepiece to be treated to immersive stereoscopic visuals. Unfortunately, those graphics came exclusively in shades of red on black, and reviewers complained of it making them feel unwell, and of the awkwardness of simply getting it lined up properly. It bombed, and Nintendo cut their losses within months to focus fully on 1996's N64.
Three to play: *Jack Bros.* (1995), *Red Alarm* (1995), *Teleroboxer* (1995)

 AMSTRAD GX4000
Launched: 1990 **Discontinued:** 1991
Pitch: Amstrad wanted a slice of the console pie, and the 8-bit GX4000 was the company's one and only attempt at producing a games-exclusive system. Never officially made available outside of Europe, the GX4000's arrival just as the Mega Drive and Super Nintendo were finding momentum killed it before it had a chance to prove itself. A lack of games added to the console's misery – only twenty-seven were ever released – and it was very quickly put out to pasture.
Three to play: *Burnin' Rubber* (1990), *Navy SEALS* (1990), *Switchblade* (1991)

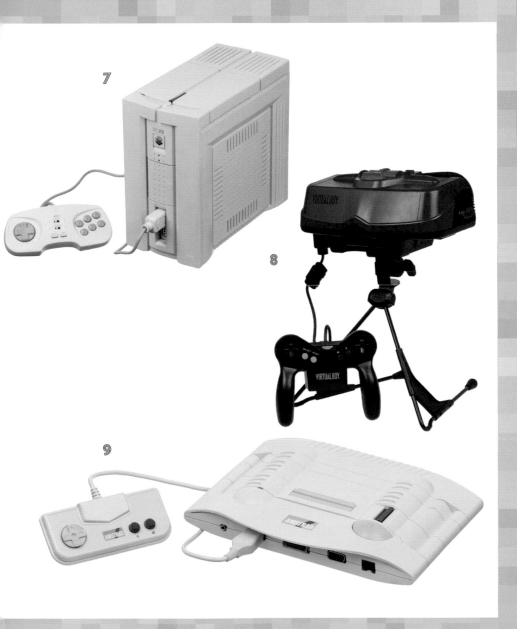

7

8

9

9 SONY PLAYSTATION

NINTENDO PLAY STATION

The roots of the PlayStation – Sony's debut console, launched in December 1994 and the first games system to sell 100 million units – stretch back to 1988, and a partnership with Nintendo.

 The 16-bit Super Famicom / Super Nintendo was already in development at the time. The *Mario* makers joined forces with Sony, the latter's team led by engineer Ken Kutaragi, on a CD-ROM drive to complement their new console, the Super NES CD-ROM System, or SNES-CD. Sony for its part was keen on producing a standalone system of its own that would play cartridge and CD-ROM games without a Super Nintendo.

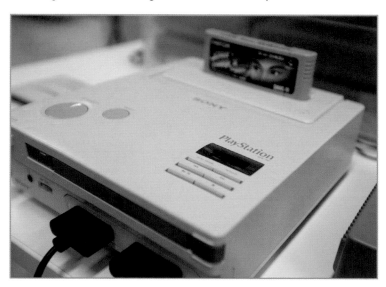

Everything seemed to be going well when a prototype of Sony's new console, compatible with the SNES library, was unveiled at the trade-only Consumer Electronics Show (CES) in June 1991. Sony called the machine the 'Play Station'. The very next day, however, Nintendo announced that it would be switching to work on its development of a CD-ROM add-on for the SNES with Philips, dropping Sony.

Kutaragi, who'd designed the sound chip inside the SNES, was upset by the decision. After a brief, go-nowhere conversation with SEGA, he decided to pursue the Play Station project within Sony. He gained the full support of the company's then-president, Norio Ohga, and the Sony Computer Entertainment (SCE) division was formally founded in November 1993. It would go on to deliver the console that ultimately ruled the 32-bit era.

X MARKS THE SPOT

For a while, Sony and Nintendo remained courteous, and the Play Station was compatible with SNES games. But by the time SCE was set up, the focus had shifted to a console capable of handling 3D polygon graphics inspired by SEGA's arcade hit *Virtua Fighter*. Previous designs were scrapped and Sony started afresh on a system all of its own in early 1993.

The first reports about Sony's new project referred to the console by its internal code name 'PSX', and the original PlayStation is still regularly called the PSX today. SCE's American arm even wanted to release the console with PSX as its official name, but the decision was made to lose the gap that'd featured in the Nintendo collaboration, and PlayStation became the brand for Sony's breakthrough game console.

Having seen the 3DO and Atari Jaguar fail, largely due to the shortage of third-party software, Sony moved quickly to attract high-quality studios to its PlayStation system. It gained the support of Namco – responsible for one of the system's finest launch titles in all territories, the superlative arcade driving game *Ridge Racer* – and bought British developer and publisher Psygnosis, bringing *3D Lemmings*, rail shooter *Novastorm* and futuristic racer *Wipeout* to the PlayStation in time for its September 1995 European release.

Before the PlayStation came west, it launched in Japan to long queues and sold-out notices. Three hundred thousand units were sold in thirty days, and the fuse was lit for an explosive international rollout. At 1995's Electronic Entertainment Expo, held in Los Angeles in May, the PlayStation stole the show from SEGA's Saturn and Nintendo's ill-fated Virtual Boy. It was at E3 that the US price was announced: $299, a whole $100 less than SEGA's console.

The Saturn was officially launched during E3, surprising most in attendance, whereas the PlayStation wasn't due to come out until 9 September. But with its pricing, Sony had dealt a blow to SEGA that the architects of the *Sonic* series would never recover from.

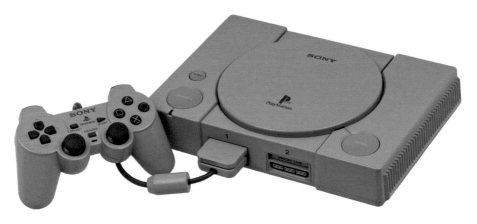

THE PLAYSTATION'S CURIOUS CONTROLLER

With the PlayStation designed from the ground up to support 3D polygon games, its controller had to be different from those that had come before. Sony's solution was the addition of shoulder buttons, one on each side of the pad, intended to alter the functionality of the face buttons – the cross, triangle, circle and square. In a 1997 interview Ken Kutaragi said of the pad's design: 'We probably spent as much time on the joypad's development as we did on the body of the [PlayStation itself].'

Eventually, these buttons – L2 and R2 – would become analogue triggers, brilliant for driving games. What's never changed, however, is the layout of the face buttons. Look at a modern PlayStation pad, like the PS4's DualShock 4, and the circle is just where it was back in 1994. And those symbols actually mean something too, as explained by the controller's designer, Teiyu Goto.

The order of the symbols is significant: from the circle, clockwise, to the triangle, they are in the same order that young children learn to draw shapes.

Point of view, or direction

Represents a sheet of paper; intended to access a game's menu

No

Yes

WIPEOUT

Psygnosis's 2052-set racer mixed blisteringly fast antigravity action with music from British dance culture. Guest artists – including The Chemical Brothers and Orbital – featured alongside a core original soundtrack by electronic musician CoLD SToRAGE, imbuing the game with an uncommonly cool vibe.

On release it was installed in a number of British clubs, and its marketing directly targeted older players – those with disposable income who partied on the weekends and wanted to bring something with high-adrenaline appeal home with them. The PlayStation couldn't have hoped for a more on-the-pulse launch title for its European push in the autumn of 1995.

RESIDENT EVIL

Inspired by its own 1989 Famicom game *Sweet Home*, and initially commissioned as a remake of said haunted-house-set role-player, Capcom's *Resident Evil* revolutionized the survival horror gaming genre. Director Shinji Mikami took what began as a Super Nintendo project and transformed it into a PlayStation essential, a game that had friends getting together to pass the pad as they explored the zombie-infested Spencer Mansion, each creaking door leading to another encounter with the shambling undead, infected Dobermanns and even a giant mutant spider.

With limited resources available to the player at any one time, and strictly rationed ammo, *Resident Evil* wasn't a power fantasy like so many

action games of the era (or since). Rather, it was a testing experience, of small steps taken in trepidation, the player always wary of what awaits them in the next room. A little hammy in some respects – the live-action sequences and voice acting are laughable – *Resident Evil* nevertheless

made a massive impression, garnering sales of almost 3 million, numerous sequels, a movie franchise and a Netflix TV series.

CRASH BANDICOOT

The PlayStation didn't have a mascot, as such, at launch – no Sonic or Mario to call its own. But in 1996, *Crash Bandicoot* delivered an anthropomorphic PS icon. This 3D platformer's titular protagonist was developed by California-based Naughty Dog with the mascot role in mind: its early code name, 'Sonic's Ass', was a reference to its ambitions (and behind-the-character camera position).

The character himself, first named Willie the Wombat before becoming a bandicoot with a less mockable moniker, went through a few iterations before his creators, including Naughty Dog co-founders Jason Rubin and Andy Gavin, settled on the jovially animated, wide-smiling critter that gamers ultimately fell for.

Crash's backstory is one of genetic engineering at the hands of the series' main villain, Doctor Neo Cortex – but really, *Crash Bandicoot* was more about precision platforming, crate smashing and Wumpa fruit collecting (amass one hundred and gain an extra life, as per classic gaming conventions) than narrative clout. It set new visual standards for games of its genre, with its many and varied levels – incorporating castles, waterfalls, jungles and even a power station – appearing more detailed than Nintendo's *Super Mario 64* of the same year.

A vast number of sequels and spin-offs followed *Crash Bandicoot*'s success. It stands as the eighth bestselling original PlayStation title, with almost 7 million sales, and was remade in stunning HD in 2017 as part of the *N. Sane Trilogy*, available for PS4, PC, Xbox One and Nintendo Switch. That collection outsold the original individual *Crash* games, racing all the way to 10 million units and counting.

GRAN TURISMO

The original PlayStation's bestselling game, with close to 11 million copies sold, 1997's *Gran Turismo* was a racing simulator that, in contrast to the fantastical ships of *Wipeout*, rooted itself wholly in reality. Having taken five years to produce, *Gran Turismo* showcased a wealth of recognizable cars from famous manufacturers like Honda, Dodge and Nissan.

One of the reasons the game took so long was developer Polyphony Digital's insistence on engineering a level of AI competition previously unseen in racing games. Their commitment – which went above and beyond, with producer Kazunori Yamauchi saying that he was at home for 'only four days a year' during *Gran*

Turismo's making – was rewarded with near-perfect reviews praising the presentation and, of course, amazing sales. The game's soundtrack was a hit with players too, with indie-rock artists like Idlewild, Ash and Feeder finding new fans through their songs' inclusion.

METAL GEAR SOLID

Metal Gear Solid, released in 1998 and selling 6 million copies on the PlayStation, was film aficionado Hideo Kojima's first opportunity to bring a truly cinematic feel to his video-game work. Having made short films in his youth prior to joining Konami in 1986, Kojima made full use of the CD-ROM format to fill this stealth action game, set in a future 2005, with the kinds of camera shots, character complexity and carefully choreographed set pieces that moviegoers were used to seeing.

And these were on top of a series lore so befuddling it would take

another book's worth of explanation to successfully untangle. It memorably breaks the fourth wall too, like when the boss character Psycho Mantis 'reads' the player's memory card to make a reference to another game's save file (albeit only if it matches one of a limited list, including Konami's own *Castlevania* and

Vandal Hearts series). The reception was overwhelmingly positive, with reviewers deeming *Metal Gear Solid* not just one of the best games ever made, but a work of art.

Solid was the third game in the *Metal Gear* series, which started in 1987 on the MSX2 before being ported to the Famicom / NES and spinning out to a total of nineteen standalone releases thus far. It made a star of its protagonist, Solid Snake, real name David, sometimes known as Iroquois Pliskin. Snake has appeared in a wealth of games outside of the *Metal Gear* franchise, including Nintendo's *Super Smash Bros.* series and Sony's *Ape Escape* games; he's even faced off against the *Transformers*' Optimus Prime and Megatron in the bizarre, Japan-only *DreamMix TV World Fighters*. Quite the CV.

FINAL FANTASY VII

As its name implies, this was the seventh *Final Fantasy* series game produced by Square (now Square Enix). But unlike the six role-playing releases before it, 1997's *Final Fantasy VII* was the first title in the franchise to debut on anything other than a Nintendo console. The NES and SNES had been the launch platforms for the previous *Final Fantasy* adventures, but Square's ambitions for its new game, whose story was unconnected to those of past entries, exceeded Nintendo's hardware of the time.

What began as a SNES project before considering the Nintendo 64 as a destination, ultimately came to the PlayStation. *Final Fantasy VII* filled the PlayStation's CD-ROMs with sublime CGI sequences, gorgeously animated summons and enough main storyline and side-quest distractions to fill over three days of non-stop play. Nintendo wasn't happy, swearing to cut ties with Square, but the sides have since made up, and *Final Fantasy VII* finally came to a Nintendo console, the Switch, in 2019. Just a twenty-two-year delay, there.

Famous for so many reasons – the mystery surrounding central protagonist Cloud Strife and his oversized Buster sword; its soundtrack, by Nobuo Uematsu, full of catchy melodies, from melancholic motifs to the cheery Chocobo theme; and the shocking fate of key party member Aerith Gainsborough – *Final Fantasy VII* remains a classic today. It helped popularize Japanese role-players in the West, with gameplay systems and stories more intricate and deeper than those *Zelda* offered, and spans 2003's *Compilation of Final Fantasy VII* mini franchise, with three further video games, the *Advent Children* animated movie and more.

TEKKEN

First released into arcades in 1994, it was *Tekken*'s port to PlayStation a year later that saw Namco's 3D fighter become a massive global hit. Taking the *Street Fighter* model of one-on-one combat into the realm of polygons, *Tekken* might never have reached the level of character recognition that Capcom's fighter enjoys – more people have probably heard of Ryu and Ken than Anna and Jack – but its million-plus sales were the start of something, and by the time of *Tekken 3*, released for PlayStation in 1998, Namco had refined its franchise into a masterpiece.

The third game received several near-perfect review scores, sold in excess of 8 million copies, and is regarded as one of the greatest video

games ever. Having fine-tuned the leg sweeps and uppercuts of its predecessors, *Tekken 3*'s easy-to-learn, challenging-to-master virtual combat, with intuitive and responsive controls, make it as rewarding to pick up today as it was in the late 1990s.

THE PLAYSTATION TOP TEN

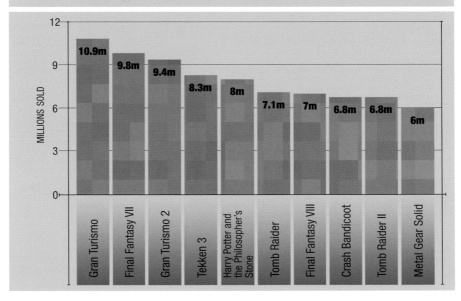

TONY HAWK'S PRO SKATER

Skateboarding games existed long before Tony Hawk put his name to this grind 'em up that debuted on the PlayStation in 1999 before porting to Nintendo 64, SEGA Dreamcast and more. But once *Pro Skater* – retitled *Tony Hawk's Skateboarding* in the UK and Australia – was out in the wild, it made the likes of *Skate or Die!* and *California Games* look like total relics.

Publisher Activision saw an opportunity to cash in on the popularity of the X Games – events featuring extreme sports and musical performances – and instructed Neversoft to deliver an experience that encapsulated what those festivals of boards and beats were all about. And how they succeeded – with a roster of pro-skaters to choose from (not just Hawk), tricks like the board-spinning 360 shove-it and the aerial Indy nosebone to nail around a selection of courses, and music from bands like Dead Kennedys and The Vandals, *Tony Hawk's Pro Skater* was a critical and commercial smash across several platforms. A remaster of this game and its sequel was released as *Tony Hawk's Pro Skater 1 + 2* in 2020.

ANIMAL ADVENTURERS

While Sonic the Hedgehog and Crash Bandicoot became famous around the world, many anthropomorphized heroes didn't fare anywhere near so well. Here are just a few animal adventurers who leaped (or skipped, or flew) their way through games of the 1990s, with differing levels of success.

JAMES POND

Animal in question: A mudskipper who's also a secret agent, some of the time
Debuted: *James Pond: Underwater Agent* (1990)
Best showing: *James Pond 2: Robocod* (1991)
Unique attributes: In *James Pond 2*, our fishy friend's high-tech armour allows him to extend his body vertically, to access otherwise unreachable areas

BUBSY

Animal in question: A bobcat who owns the world's largest collection of yarn balls

Debuted: *Bubsy in: Claws Encounters of the Furred Kind* (1993)

Best showing: *Bubsy 2* (1994)

Unique attributes: Bubsy's appetite for yarn balls knows no limits, and he'll do anything to prevent aliens making off with them

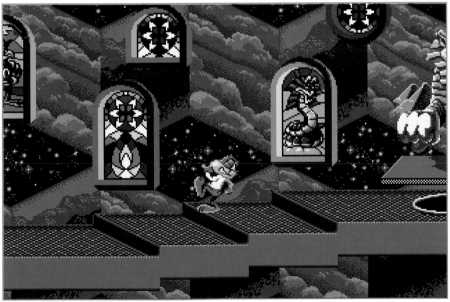

EARTHWORM JIM
Animal in question: An earthworm inside a 'Super Suit' that grants him human-like movement
Debuted: *Earthworm Jim* (1994)
Best showing: *Earthworm Jim HD* (2010)
Unique attributes: Jim can use himself as a weapon, with the Super Suit yanking him from his comfy cocoon and then using his body as a whip

CONKER
Animal in question: A foul-mouthed squirrel with a taste for booze
Debuted: *Diddy Kong Racing* (1997)
Best showing: *Conker's Bad Fur Day* (2001)
Unique attributes: Conker's blue language and bad-taste humour make him a very singular figure in the field of platforming animal heroes

SPARKSTER

Animal in question: An opossum in blue armour, and usually wielding a whopping sword
Debuted: *Rocket Knight Adventures* (1993)
Best showing: *Rocket Knight Adventures* (1993)
Unique attributes: How many opossums have you ever seen walking around with a massive blade in their paws, not to mention a jetpack on their back?

GEX

Animal in question: A TV-addict gecko from the Hawaiian island of Maui
Debuted: *Gex* (1995)
Best showing: *Gex: Enter the Gecko* (1998)
Unique attributes: The wise-cracking Gex is a millionaire, not exactly a common quality among reptiles

SPYRO

Animal in question: A brash, fire-breathing purple dragon

Debuted: *Spyro the Dragon* (1998)

Best showing: *Spyro Reignited Trilogy* (2018)

Unique attributes: It's not just heat that Spyro brings, as he also spits ice, lightning and bubbles across his series

CROC

Animal in question: A crocodile that prefers to walk around on his rear two legs
Debuted: *Croc: Legend of the Gobbos* (1997)
Best showing: *Croc: Legend of the Gobbos* (1997)
Unique attributes: Whereas most crocodiles aren't known for their athleticism, this one can navigate monkey bars and even climb walls

AMERICA VS JAPAN

The Saturn represents SEGA's slip from gaming's top table, and its failure in the 32-bit era, against competition from Sony's PlayStation and the Nintendo 64, had as much to do with internal conflicts as inferiority compared to its peers.

SEGA of Japan and SEGA of America were at loggerheads over how to handle the end of the Mega Drive / Genesis. In the US, the preference was to extend the 16-bit machine's lifespan with the 32X (below opposite), a plug-in peripheral providing 32-bit capabilities for the Genesis. But Japan's focus was on the Saturn (below, and above opposite), SEGA's true 32-bit system.

Ultimately, the platforms clashed: the 32X launched in the US on 21 November 1994, and the Saturn released in Japan the next day, immediately presenting SEGA's Western fans with an awkward choice: do you buy a stopgap device, or wait for the Saturn?

This state of limbo was only one of the Saturn's problems. Another was the console's internal

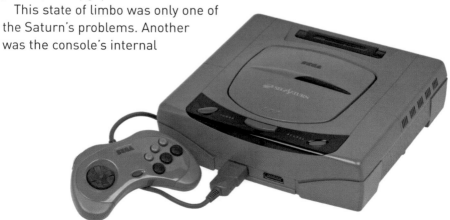

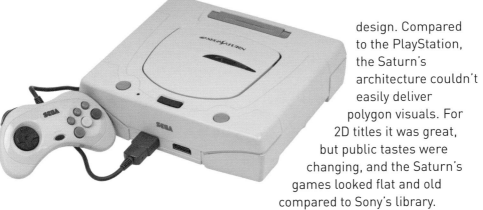

design. Compared to the PlayStation, the Saturn's architecture couldn't easily deliver polygon visuals. For 2D titles it was great, but public tastes were changing, and the Saturn's games looked flat and old compared to Sony's library.

As early as the summer of 1997, two years after it had launched in the West (hitting North America in May 1995, and Europe two months later), SEGA of America announced that the Saturn was no longer part of the company's future. It was discontinued in Europe and America in 1998, and Japan in 2000, with global sales of under 10 million units. And despite the excellence of its swansong system, the Dreamcast, SEGA would never recover from this commercial failure.

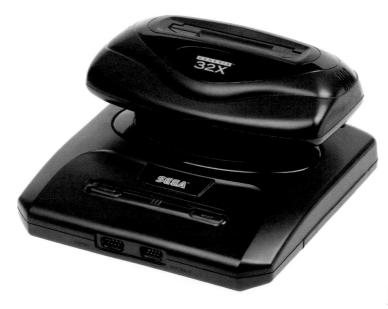

SONIC WHO?

In the mid-1990s, arcades were booming in Japan – and SEGA was one of the biggest names in the market. It subsequently converted a number of its arcade hits to the Saturn, with *Virtua Fighter* and *Daytona USA* as launch titles in both North America and Europe.

But what worked in Japan didn't always translate internationally. When the Genesis launched in the US, it swiftly became a home for sports titles bearing famous names such as *John Madden Football* and *Tommy Lasorda Baseball*. These helped SEGA conquer the American market, but analogous titles were slower to reach the Saturn, impacting the console's sales. By the end of 1996, the PlayStation had sold 2.9 million units in the US and the Saturn 1.2 million, despite launching four months earlier.

Some of SEGA's coin-op conversions also flattered to deceive. The eye-catching racer *Daytona USA* featured no additional tracks in its first Saturn release, and ran at a third of the arcade game's sixty frames per second. It didn't make the best impression, especially next to the PlayStation's exceptional port of Namco's *Ridge Racer*.

A number of SEGA's big 16-bit franchises were also bizarrely absent from the Saturn's library. There was no new *Streets of Rage* or *Phantasy Star* game, no major *Sonic the Hedgehog* title to rival *Super Mario 64* or *Crash Bandicoot*. This lack of familiar faces compromised the Saturn's appeal.

VIRTUA FIGHTER

The world's first 3D fighting game, 1993's *Virtua Fighter* lit up arcades and was an easy pick for the Saturn's 1994 Japanese launch line-up. Designed by *Out Run* creator Yu Suzuki alongside Seiichi Ishii (who'd co-designed 1992's

3D racer *Virtua Racing*), *Virtua Fighter* uses just three buttons – punch, kick and guard – to deliver an unexpectedly deep experience.

Moves could be combined into combos or used in sync with certain directional movements. Cancelling is also a big part of the game's appeal – tapping guard just before a blow lands would retract the strike, but potentially also prompt your opponent to take action to protect themselves from it, leaving them open for an alternative attack.

The arcade game generated massive profits for SEGA, and the Saturn port earned rave reviews, with the character Akira Yuki becoming a mascot for the *Virtua Fighter* franchise (with *Virtua Racing*, 'Virtua' itself became a kind of series within SEGA). The game's sequel, *Virtua Fighter 2*, sold 1.3 million units in Japan alone, and with 2012's *Virtua Fighter 5: Final Showdown* for HD consoles and 2014's *Virtua Fighter: Fever Combo* for mobile devices, the franchise remains firmly established in the twenty-first century.

DAYTONA USA AND SEGA RALLY CHAMPIONSHIP

Released into arcades in 1993 and '94 respectively, these two racers were huge for SEGA, and rank among the bestselling titles for the Saturn. But neither port was quite up to the quality of its coin-op predecessor, with *Daytona USA*, in particular, suffering from noticeably sluggish gameplay. (It was improved in 1996, with the *Championship Circuit Edition*.)

Still, both games represent significant first steps for their parent series. Daytona would hit its home-version high with 2011's enhanced port of the original for PlayStation 3 and Xbox 360, and a reboot reached arcades in 2017, while *Sega Rally 2* came out for the Dreamcast in 1999, after debuting in arcades the year before, to a very positive reception. The home-exclusive *Sega Rally Revo* attracted modest acclaim in 2007 before *Sega Rally 3* started crunching loose change in 2008.

TOMB RAIDER

Often seen as a PlayStation cornerstone – it sold over 7 million copies on Sony's system – British studio Core Design's *Tomb Raider* came out first on the Saturn. But SEGA's time-limited exclusive didn't massively benefit the console, as 1996's *Tomb Raider* was precisely the kind of 3D adventure that the PlayStation handled better. Sony's version – developed concurrently with the SEGA release – appeared crisper and brighter, and putting the two games side by side illustrated the PlayStation's superiority at generating 3D spaces.

Platform differences aside, *Tomb Raider* was unanimously praised upon its release. A fully 3D adventure like this was unprecedented – Capcom's *Resident Evil* had used pre-rendered backgrounds earlier in the year – and reviewers instantly praised Core's efforts. The game left an immediate impression with players too, with select set pieces – battles with ancient mutants, navigation of trap-laden ruins, an encounter with a *Tyrannosaurus rex* and a visit to Atlantis – becoming playground and workplace talking points.

The breakout star of *Tomb Raider* was its protagonist, Lara Croft. As recognizable today as Mario or Sonic, Lara's popularity saw her advertising SEAT cars and Lucozade soft drinks; appearing in comics, novels and movies; and becoming a video-game sex symbol. Her exaggerated

physical features have been toned down since the 1990s, but Lara remains prominent in gaming, with 2018's *Shadow of the Tomb Raider* concluding a rebooted origin-story trilogy that started in 2013.

Lara's designer, Toby Gard, went through five different designs before settling on the character we met in 1996. Originally, the team at Core had an Indiana Jones-like male protagonist in mind, but Gard preferred a strong and determined female lead, the opposite of the damsel-in-distress archetypes of countless older games. But Gard, disappointed with the lack of control he retained over Lara's image, left Core in 1997, and wouldn't return to the character he created until 2006's *Tomb Raider: Legend*.

FIVE LARA CROFT FACTS

1. Lara's surname was initially Cruz, before publisher Eidos Interactive insisted it be changed to something more British-sounding. Core's team landed on Croft by flicking through a phone book.
2. Lara's popularity saw her appear on the cover of several magazines that weren't games-focused, including *The Face*, *Newsweek* and *TIME.*
3. A *Tomb Raider* movie script was completed in 1998, but the Angelina Jolie-fronted film was hit by delays and didn't come out until 2001. A critical panning awaited.
4. Core Design, which closed in 2010, was based in Derby. If you visit the English city's centre today, you'll find a road named after its famous creation: Lara Croft Way.
5. Five actresses have voiced Lara in her mainline video game adventures: Shelley Blond (1996), Judith Gibbons (1998–2000), Jonell Elliott (2000–2006), Keeley Hawes (2006–2013), and Camilla Luddington (2013 to date).

PANZER DRAGOON

A rare SEGA series that began on the Saturn, *Panzer Dragoon* has, to date, encompassed six standalone video games. The first eponymous title was a rail shooter with some wonderfully original dragon designs. It released in 1995 and, unlike a lot of the Saturn's best first-party games, wasn't an arcade port – it had been made from the ground up for SEGA's console. Directed by Yukio Futatsugi, *Panzer Dragoon* earned excellent reviews

and even attracted the attention of Steven Spielberg, who reportedly complimented its developers for their work at E3 in 1995. A role-playing spin-off, *Panzer Dragoon Saga*, came out in 1998 and is, according to GameRankings.com, the highest-rated Saturn game, with a score of 92.46%.

NIGHTS INTO DREAMS ...

Another Saturn original that earned plaudits aplenty, 1996's *Nights into Dreams ...* was the work of SEGA's *Sonic* team. Conceived as a game focused, like Sonic, on speed and style, its protagonist Nights, or NiGHTS, flies rather than runs.

The game's development was led by Yuji Naka, programmer on 1991's *Sonic the Hedgehog; Sonic 3* senior designer Takashi Iizuka; and Sonic's

original artist Naoto Ohshima. The result was a gorgeous success, declared a 'perfect evolution' of the *Sonic* formula by *Computer and Video Games* magazine.

Nights into Dreams ... was also notable for being bundled with the 3D Control Pad, which featured an analogue stick and shoulder triggers – the first mainstream pad to have the latter, which would later become standard on console controllers.

11 NINTENDO 64

PROJECT REALITY AND ULTRA 64

Long before the SNES had reached the end of its lifespan, Nintendo was developing a successor. Silicon Graphics Inc – an American company focused on high-end 3D graphics, often used in the movie trade (its computers produced the liquid-metal effects for *Terminator 2: Judgment Day*) – signed a deal with the Japanese gaming giant in early 1993 to develop the CPU for Nintendo's next home system.

That summer, then-president and CEO of Nintendo, Hiroshi Yamauchi, announced Project Reality – the working name for the new console – alongside SGI's founder James Clark, and the world waited with feverish anticipation.

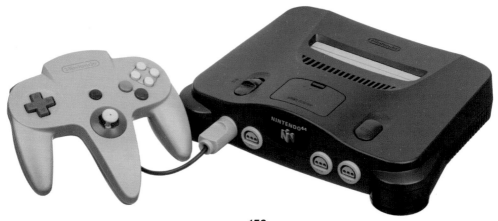

And it waited. And waited some more. Come the summer of 1994, Project Reality had become Ultra 64, but the console was still a long way from being finished. In January 1995, Nintendo announced that its chips for the Ultra 64 were finally ready – but this wasn't true at all, with internal disruption at SGI and underperforming components setting production back. It was purely a defensive move – SEGA's Saturn and Sony's PlayStation were already on sale, and Nintendo had to say that its new system was coming sooner rather than later.

But later was ultimately the outcome, with the Ultra 64 – ultimately called the Nintendo 64 (or N64) (opposite) – missing its intended Christmas 1995 release window, as well as a revised April date. It eventually came out in Japan in June 1996, North America in September of the same year, and Europe in March 1997.

CARTRIDGE IS KING

A key difference between the N64 and its generational peers, the PlayStation and Saturn, is that Nintendo used cartridges, or Game Paks, for its games, not CD-ROMs. Both Yamauchi and Satoru Iwata, president and CEO of Nintendo from 2002 until his death in 2015, claimed that cartridges allowed for quicker loading and helped reduce the console's cost, as CD drives were expensive. Another reason for Nintendo avoiding CDs was to combat piracy – it was much harder to duplicate a cartridge than a CD-ROM.

However, storage was a problem for the N64 Game Paks. A PlayStation CD-ROM could hold 650MB of data; the most a Game Pak could manage was 64MB (used for very few games, including *Conker's Bad Fur Day* and

Resident Evil 2). The Japan-only 64DD peripheral (previous page and below), which used a magnetic disc as its medium, doubled megabytes of storage, but it was rarely used and sold little more than 15,000 units. Some high-profile games that were meant to use the 64DD, like *The Legend of Zelda: Ocarina of Time*, were ultimately released on cartridge alone, leaving the add-on without a killer app.

Rather more successful was the Expansion Pak (below top), which could be used without the 64DD. It was essential for running three N64 cartridges – *Perfect Dark*, *Donkey Kong 64*, and T*he Legend of Zelda: Majora's Mask* – and graphically enhanced a number of other titles.

SUPER MARIO 64

Another Nintendo console, another Super Mario game as a launch title. So far, so predictable. But *Super Mario 64* might just be the very best *Mario* platformer of all time. The first game to receive a perfect 10/10 score in notoriously hard-to-please British magazine *Edge*, it not only represented an exciting new way to play as Mario, helping drive the N64 to half a million US sales in its first four months (and to Sony- and SEGA-beating figures in 1997), but also showed developers around the world how to make a successful 3D platformer.

With its controllable camera allowing players to adjust their perspective on the game-world (making negotiation of tricky sequences that little bit easier), and the N64 controller's analogue stick (making movement in 3D all the more precise), *Super Mario 64* set pioneering precedents in the field – and this from a character celebrating his fifteenth anniversary.

It wasn't just platformers it influenced, either, as Dan Houser of Rockstar Games fame (*Grand Theft Auto*, *Red Dead Redemption*) told the *New York Times* in 2012: 'Anyone who makes 3D games who says they've not borrowed something from Mario or Zelda [on the N64] is lying.'

The bestselling game on N64, *Super Mario 64* sold almost 12 million copies, with a remake released for the Nintendo DS handheld in 2004 (a launch title for that system). What the game didn't get was a sequel on the N64 itself. One was planned for the 64DD but didn't come to fruition, largely due to the peripheral never taking off; and a 2015 fan remake, in glorious HD, was (understandably) shut down by Nintendo's legal department. More recently, the original *Super Mario 64* has become playable on Switch, via 2020's *Super Mario All-Stars 3D* compilation and 2021's rollout of N64 games on the Switch Online service.

SUPER SMASH BROS.

Many Nintendo-published titles for the N64 were from franchises stretching back a generation or two – the likes of *Mario Kart 64*, *Kirby 64: The Crystal Shards* and *Yoshi's Story*. But 1999's *Super Smash Bros.* was something new, kicking off a series that's been a mainstay of Nintendo's home consoles ever since. A frenetic multiplayer fighting game, it threw characters from the worlds of *Pokémon*, *Mario*, *Metroid*, *Zelda*, *Star Fox*, *F-Zero* and more into battle with each other.

Twelve playable characters were available in 1999's debut game, each with unique moves tied to abilities seen in previous appearances. Mario led the way, of course, joined by his brother Luigi, Samus, Captain Falcon, Pikachu, Jigglypuff, Yoshi, Kirby, Link, Fox, Donkey Kong and Ness (from *EarthBound*), with stages set in locations such as *Super Mario*'s Peach's Castle, Saffron City from *Pokémon*, and *Metroid*'s Planet Zebes.

The roster grew over iterations, and 2018's *Super Smash Bros. Ultimate* for Switch featured seventy-four characters at launch, with more added via downloadable content. The series has welcomed a raft of fighters from outside of Nintendo-only franchises too, such as *Metal Gear*'s Solid Snake,

Cloud Strife from *Final Fantasy VII* and Mario's one-time fiercest rival, Sonic the Hedgehog.

THE LEGEND OF ZELDA: OCARINA OF TIME

The *Zelda* series' first 3D adventure, *Ocarina of Time* is the highest-rated video game of all time according to reviews aggregator Metacritic.com, with a score of 99/100 – quite the accomplishment, given it came out back in 1998, and gamers have been treated to several masterpieces since. But playing the game today swiftly confirms why it was, and remains, so special: this is a role-player of considerable depth and detail, of narrative intrigue and mechanical innovation, that transcends its dated visuals to feel as much of a grand accomplishment as it did more than twenty years ago.

The basics of *Ocarina of Time* are largely unchanged from previous Zelda games: the hero is Link, the baddie is Ganon (well, Ganondorf here), and Princess Zelda is both an important supporting character and a clichéd damsel in distress whom Link must rescue. Link discovers and wields the Master Sword, and the magical Triforce plays a major part in the game's plot. Where *Ocarina* really differed was its scale – even without 64DD support, it

presented a Hyrule like players had never seen, or possibly imagined, before. A series of interconnected hubs comprised an open-world whole that made simply trekking from A to B, from quest completion to the next chapter of Link's mission, an audio and visual joy.

So large was this Hyrule that Nintendo introduced a character that the *Zelda* series hadn't seen before: Link's horse, Epona. She's not absolutely essential for finishing the game, and it's quite possible to never unlock her. But *Ocarina*'s Hyrule was designed for four-legged exploration, and Epona has since become a favourite among *Zelda* fans. A direct sequel to this indisputable classic was released in 2000, also for the N64. *The Legend of Zelda: Majora's Mask* earned praise aplenty for its time loop mechanics and melancholy tone, and earned similarly high review scores.

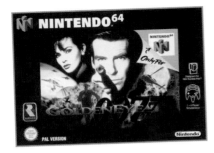

GOLDENEYE 007

Super Smash Bros. and *Mario Kart 64* were awesome local multiplayer games, but they had nothing on the four-player face-offs that the Rare-developed *GoldenEye 007* offered. Released two years after the 1995 film that inspired it, this first-person shooter features a mostly compelling single-player campaign, in which James Bond must spoil the nefarious plans of former fellow agent Alec Trevelyan; but it's playing with friends that you really feel the game come into its own.

Splitting the screen up to four ways, players could choose from a range of the *GoldenEye* movie's heroes and villains, with icons like Oddjob and Jaws unlockable; and there are game modes based on previous Bond flicks: 'The Living Daylights' sees competing players trying to hold onto a flag for the longest time; 'You Only Live Twice' gives each character two lives before they're eliminated; and 'The Man with the Golden Gun' sees kill numbers staying with the weapon in question, rather than the player, so getting a weapon off someone else would usually give you a higher score.

An unexpected hit for the N64 after disappointing previews, *GoldenEye 007* sold over 8 million copies, making it the third highest-selling title on the console. And its critical reception was superb too, with a Metacritic score of 96/100.

Rare, rather than dive into a Bond-themed sequel, instead produced more of a spiritual follow-up: 2000's *Perfect Dark*. The stealthy shooter starred another secret agent, Joanna Dark, created exclusively for the game, and

was just as revered by reviewers as its predecessor, although sales peaked at just over 3 million units.

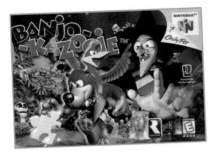

BANJO-KAZOOIE

Rare, based in Leicestershire, UK, and Nintendo were perfect partners for much of the 1990s. *Donkey Kong Country* (and its sequels) and *Killer Instinct* on the SNES were followed by *Diddy Kong Racing* – a *Mario Kart*-alike – and the aforementioned *GoldenEye 007* on the N64. *Conker's Bad Fur Day* and *Perfect Dark* would follow for Nintendo's fifth-gen system. But before those, in the summer of 1998, came *Banjo-Kazooie*, the only 3D platformer on the N64 that could claim to hold a candle to the majesty of *Super Mario 64*.

Starring a bear called Banjo and a bird called Kazooie, this colourful romp

mixes its leap-about-the-place gameplay with puzzles, several collectibles – an assortment of all-important musical notes and jigsaw pieces, necessary for unlocking next stages and extra areas within them – and non-linear environments that encouraged exploration. The pair's quest: to save Banjo's sister, Tooty, from the evil witch Gruntilda, who hopes to steal Tooty's good looks (for a bear, we guess) for herself. Inspired by *Super Mario 64*, their own *Donkey Kong Country* and Disney movies, the team at Rare aimed to create an envelope-pushing experience that players of any age could enjoy (something that definitely wasn't on the cards when they made *Conker's Bad Fur Day*, full as it is with bad language and potty humour).

A sequel, *Banjo-Tooie*, was released for the N64 in 2000, and a third game, *Banjo-Kazooie: Grunty's Revenge,* took the first game's protagonists onto handhelds, launching for the Game Boy Advance in 2003. After 2008's *Banjo-Kazooie: Nuts & Bolts* on the Xbox 360 – Microsoft has owned Rare outright since 2002 – the series received a spiritual successor in the shape of 2017's *Yooka-Laylee*, developed by a team of ex-Rare employees under the banner of Playtonic Games.

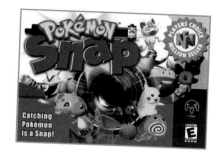

POKÉMON STADIUM AND SNAP

With the main *Pokémon* RPG series sticking to handhelds – it's only with the Switch's *Pokémon: Let's Go*, in 2018, that the catch 'em all breed of releases has featured TV play – the N64 received a couple of spin-off games. 1999's *Pokémon Stadium* focused exclusively on battling, without any story elements; *Pokémon Snap* of the same year opted for a less violent approach, inviting the player to take photos of the world-famous pocket monsters.

A total of sixty-three of the critters can be snapped across seven linear, on-rails levels – but stages can be replayed with new equipment to discover previously hidden beasts. Despite a mixed critical reception, the strength of the *Pokémon* brand carried *Snap* to over 3.6 million sales, whereas *Stadium* racked up an even more impressive 5.4 million. *Pokémon*

might have been best on the go, but even its sideshow offerings were incredibly popular, and a sequel to *Pokémon Snap* was released for Nintendo Switch in 2021.

ANIMAL CROSSING

Though it only came to Western markets with its US GameCube release in 2002, Nintendo's popular life-simulation series *Animal Crossing* began on the N64, with the original releasing in Japan in April 2001 under the title of *Dōbutsu no Mori*.

Considered a 'communication game' by Nintendo, the focus was on integrating the player's anthropomorphic character within a village of cutesy animal neighbours, all of whom go about their business by a real-time clock (which can run for several years), with the option of sharing the same village with friends via pass-the-pad multiplayer – a chilled experience quite unlike the fast-paced action of so many other games on these pages.

Animal Crossing's GameCube version brought with it a host of upgrades and new features. Among these were its 'games within a game': the N64 release incorporated a handful of NES titles, playable within it via emulation, and the GameCube update expanded this library considerably. Titles included *Donkey Kong*, *Punch-Out!!* and *Balloon Fight*.

Animal Crossing's international release saw it achieve widespread acclaim, including numerous industry awards for its gentle innovation and curious uniqueness, and the series it spawned has sold over 30 million units across platforms like the Nintendo 3DS and Wii.

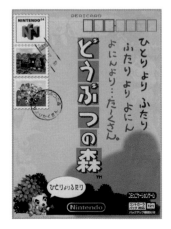

12 CONSOLE GAMING'S SIXTH GENERATION

GAMING'S MARCH TO MODERNITY

Home gaming's sixth generation began in 1998 with SEGA's Dreamcast, which, along with its competitors, introduced hardware features and modes of play now commonplace. It's these consoles that bridge the gap between retro gaming and the medium as it is today.

Controllers got analogue sticks as standard, with triggers and face buttons gaining pressure sensitivity. All game-makers started to use optical discs for their games, Nintendo standing out with its mini DVD format. Multimedia was a consideration too: Sony's decision to make 2000's PlayStation 2 compatible with DVD movies gave it a massive advantage.

Online gaming hit its stride – all four major consoles offered games you could play with your friends over the internet. This was delivered with wildly different levels of commitment, however; SEGA's Dreamcast came with a built-in modem, but Nintendo's GameCube required an adapter to connect to the web.

The sixth generation witnessed a power struggle between established names and newcomers. The PlayStation 2 became the biggest console of all time, with sales over 155 million, but the old guard of SEGA and Nintendo also lost ground to Microsoft's Xbox and its Xbox Live online service. The *Mario* makers would survive, coming back with the Wii, while the Dreamcast would be SEGA's final home console, the company exiting the market after eighteen years.

SEGA DREAMCAST

SEGA was struggling following the Saturn's lacklustre sales but pressed ahead with another system. And with online options and second-screen functionality via its Visual Memory Units, many who bought the Dreamcast absolutely adored it. Sadly, that wasn't nearly enough people.

Produced more economically than past consoles, the Dreamcast was closer to a PC on the inside than anything SEGA had previously designed. Some 5,000 names were put forward before 'Dreamcast' was selected; SEGA even considered taking its name off the device entirely due to the Saturn's failure.

Strong Japanese launch sales soon slowed, and the console couldn't eat away at PlayStation's share of the international market. The announcement of the PlayStation 2 in early 1999, before the US and European launches of the Dreamcast, saw consumers hesitate, many preferring to wait for Sony's next system than switch to SEGA. Sales stalled shy of 10 million units.

Dreamcast production was cancelled by April 2001 – *before* the GameCube and Xbox debuted – marking the end of SEGA's hardware output. Yet there's no doubt the Dreamcast received a fascinating range of software, from perfect arcade ports to role-players, plus some beautifully bizarre outliers, with *Seaman* and *Space Channel 5* examples of the gleeful experimentation that showed SEGA, even at the end, was a true original.

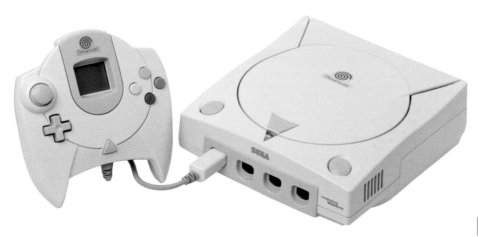

SONIC ADVENTURE

The first proper 3D *Sonic* game, *Sonic Adventure* missed the Dreamcast's Japanese launch but did release alongside it elsewhere. And with 2.5 million sales, it's the biggest seller on the system.

Adventure began as a Saturn project – but as soon as SEGA president Hayao Nakayama informed the *Sonic* team of the Dreamcast, they changed direction. SEGA wanted to create the greatest *Sonic* game of all time, mixing trademark speed and style with richly detailed 3D visuals.

What came out was certainly special – but it's debatable whether *Sonic Adventure* is the series' best entry. The somewhat forced edginess of *Adventure*, with a sleeker Sonic and new companions alongside the usual cast of Miles 'Tails' Prower (the fox), Knuckles the Echidna et al. – and including Big the Cat, whose sweet nature but general uselessness saw him appear on several critics' lists of gaming's worst characters – divided opinion. Nevertheless, it showed SEGA being bold with its most important IP, and a sequel arrived in June 2001 – after the Dreamcast had been discontinued.

As a legacy, *Sonic Adventure 2* was ported to the GameCube, representing the first time SEGA's mascot would appear on a Nintendo console.

JET SET RADIO

No game on Dreamcast was as visually loud and musically ebullient as 2000's *Jet Set Radio* (*Jet Grind Radio* in the US), which embraced pop culture – graffiti, in-line skating and hip-hop – without feeling insincere. (It helped that its developers at SEGA's in-house Smilebit studio had an average age of under twenty-five.)

The game's cel-shaded graphics – which give it the look of a terrifically vibrant, animated comic book – stand up after two decades. And with its city streets explorable at great speed,

Jet Set Radio acts as a kind of link between *Sonic Adventure* and the Dreamcast's zenith of open-world design, *Shenmue*.

SHENMUE

Gaming's most expensive project at the time, with a development cost of around $70 million, 1999's *Shenmue* was less a game and more a life simulator (with life set in 1986). The player is cast as Ryo Hazuki who, on seeing his father murdered by the sinister Lan Di, embarks on a quest for vengeance

that takes some deliriously mystical turns (and features some of the best bad voice acting ever heard).

But the star of *Shenmue* isn't one of its characters, or its many mini games – including complete versions of SEGA arcade hits *Hang-On* and *Space Harrier*. Rather, it's the world that director and producer Yu Suzuki (*Out Run*, *Virtua Fighter*) made come alive for you.

Ryo lives in the real Japanese city of Yokosuka, areas of which are recreated in *Shenmue* with such care and attention that you can visit the suburb of Dobuita after playing and immediately recognize shopfronts. (Alternatively, check out a comparison video on YouTube.) The freedom this allowed players was almost unheard of.

The game unfolds over a number of carefully planned days, with appointments that need keeping, and Ryo even has to get a job to earn enough to chase Lan Di to Hong Kong. In its quiet calmness and uncommon realness, *Shenmue* was remarkable.

But, despite sales of 1.2 million, the game's costs prevented SEGA turning a profit, and *Shenmue* was branded a commercial flop. Its cult status lived on after 2001's *Shenmue II*, however, with a 2018 crowdfunding campaign for *Shenmue III* raising over $7 million from 81,000 backers.

SOULCALIBUR

SEGA brought *Virtua Fighter 3* to Dreamcast, while Capcom supported the console with *Marvel vs. Capcom 2: New Age of Heroes* and *Street Fighter III: 3rd Strike*. But Namco's weapons-based *Soulcalibur* might be the premier one-on-one fighter on SEGA's swansong system. Showing just how advanced the Dreamcast was, the 1999 home version of *Soulcalibur* was graphically superior to the arcade

original of a year earlier, with all-new bonus features and extra modes making it a must-have.

Like *Virtua Fighter* before it, *Soulcalibur* was a game where you could just have fun playing against a friend, button-bashing them into defeat, or devote untold hours to it as you learned every nuance of each character's

combos and techniques. And its characters are a varied bunch, too, with the grotesque and mutated Nightmare standing in stark contrast to the human features of Sophitia and Xianghua.

SONY PLAYSTATION 2

With over 155 million units sold, the PlayStation 2 is the most successful console of all time. It remained supported by Sony, in Japan at least, until September 2018 – five years after its discontinuation, and five years after the launch of the eighth-generation PlayStation 4.

The reasons for its success are manifold. Sony, having stolen a march on Nintendo in the previous generation, brought more all-ages games to the PS2, particularly from Nickelodeon and Disney franchises, positioning it as a console for the whole family. It was natively backwards-compatible, so those who already had a PlayStation could keep their old games and run them on the new machine. Its DVD movie compatibility was a master stroke

too: the PS2 cost the same as many stand-alone DVD players.

 The PS2 hit stores a year and a half ahead of the Xbox and GameCube, and its instant popularity, with half a million units sold in twenty-four hours, was one of the many blows dealt to the Dreamcast. The stage was clear for Sony to dominate gaming's sixth generation – and dominate it did, to record-breaking levels.

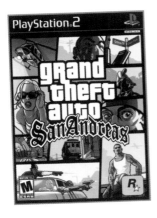

GRAND THEFT AUTO: SAN ANDREAS

The bestselling game on the PS2, 2004's *San Andreas* was the seventh entry in the *Grand Theft Auto* series, and the third to be a fully 3D experience after 2001's breakthrough *Grand Theft Auto III* and 2002's *Vice City*.

 Staged in a fictional California of 1992, and incorporating three cities, *San Andreas* was the then-largest *GTA* with a map covering thirty-three square kilometres. With themes of gangland violence, relationship pressures and police corruption, *San Andreas* tackled serious topics while retaining the series' goofy and gratuitously bloody mayhem. Voice acting from the likes of actors Samuel L. Jackson and Peter Fonda, and musicians Ice-T and Chuck D, gave it the

blockbuster feel that would become synonymous with later *GTA* entries.

KINGDOM HEARTS

One of gaming's most narratively baffling role-playing series, *Kingdom Hearts* made its debut on PS2 in 2002 and was an instant hit. But how could it not be, mixing as it did Square's *Final Fantasy* series with Disney favourites like Mickey Mouse and Donald Duck?

Kingdom Hearts sold around 5 million copies, a solid foundation for its string of sequels, spin-offs, prequels and compilations with titles like *Kingdom Hearts 3D: Dream Drop Distance* and *Kingdom Hearts HD 2.8 Final Chapter Prologue*. If you got into *Kingdom Hearts'* lore, it became a series to hold dear, evidenced by its total sales of over 30 million, and 2019's *Kingdom Hearts III* moved 5 million units in its first week alone. But to many, it's an impenetrable maze of muddled plot twists and syrupy sentimentality.

GOD OF WAR

Based on, and taking several liberties with, Greek mythology, 2005's *God of War* is a hack-and-slasher par excellence – even if its lead protagonist, Kratos, is fairly unlikeable. In his debut outing, our sex-and-violence-craving hero carves through Greek legends, slaughtering the Hydra, Medusa and Ares (the *actual* Greek god of war), accumulating a body count to make most gaming protagonists blush.

Looking past the explicit gore, *God of War* was a high-adrenaline blast that spawned a highly successful series. To date, the franchise has included a PS2 sequel, portable spin-offs, the superbly acclaimed *God of War III* for the PS3 and the even-more-celebrated *God of War* for the PS4, which moved into Norse mythology, gave Kratos a son and a softer temper, and won a bevy of industry awards in 2018 and 2019.

JAK AND DAXTER AND RATCHET & CLANK

Naughty Dog's *Jak and Daxter* and Insomniac's *Ratchet & Clank* series stand out as the PS2's best 3D platformers, the former debuting in 2001 with *The Precursor Legacy* and the latter arriving in 2002. Both were largely aimed at all ages but featured challenges enough to appease older gamers raised on the 16-bit era's more testing titles.

The Precursor Legacy tasked players with battling enemies called Lurkers, who appear in various guises from spiders to snakes to toads to sharks, and with collecting vital orbs and power cells. *Ratchet & Clank* focused more on gadgets and gizmos, with Ratchet, a cat-like 'Lombax', able to regularly upgrade his weapons, and the robot Clank often acting as

a jetpack for his larger pal as the pair take on the warmongering Blarg.

Of the two series, only *Ratchet & Clank* went the distance to contemporary consoles, with a reboot of the first game coming out on the PS4 in 2016 to great reviews (albeit accompanied by a mediocre animated movie), and the PlayStation 5-exclusive *Ratchet & Clank: Rift Apart* earning several industry awards in 2021.

GUITAR HERO

For a while, it was impossible to spy a PS2 without a plastic guitar beside it. *Guitar Hero*, released in 2005, wasn't the first rhythm-action hit by a long shot, but its use of a Gibson SG-styled controller, and a playlist that spanned tastes and generations (including songs from Queen and Franz Ferdinand), saw it hit the high notes of commercial and critical success.

A franchise was born which rocked its way through sequels aplenty until coming to what seems to be a halt with 2015's *Guitar Hero Live* – a great game, but released when tastes had drifted away from strumming along to six-

string scorchers. *Guitar Hero* as a series, though, will always have a place in gaming history – for its social party play hilarity; for its use as a tool to help children overcome injuries by encouraging dexterity; and for opening so many ears to a wealth of killer riffs, helping to increase album sales for its featured artists.

SHADOW OF THE COLOSSUS AND ICO

If *Metal Gear Solid*'s Hideo Kojima was the breakout auteur of the PlayStation, Fumito Ueda is his PS2 equivalent. The two games he directed for the platform, 2001's *Ico* and 2005's *Shadow of the Colossus*, are bona fide cult classics.

Ico, a minimalist adventure of a boy leading a girl through a fortress filled with dangers, had critics asking whether or not video games could be art (obviously, they can). *Shadow of the Colossus*, meanwhile, stripped back the open-world formula to present the player with only sixteen gargantuan creatures to defeat – a simple premise on paper, but an epic in practice, one that ends with a sense of melancholy so pronounced that it's never forgotten. The latter game received a beautiful HD remake for the PS4 in 2018 that met with unanimous critical praise.

NINTENDO GAMECUBE

The N64's successor, initially revealed in May 1999 as 'Project Dolphin', was named the GameCube by summer 2000. On its launch in September 2001, its smaller discs and distinctly toy-like looks set it apart from the PS2; and its controller was wholly individual, with differently proportioned face buttons in curious positions and a second analogue stick that appeared shrunken.

While not compatible with N64 cartridges, the GameCube could play Game Boy and Game Boy Advance titles via a Game Boy Player attachment, and GBAs themselves could connect to the system to unlock special features in select games. Strictly games-focused with limited online options, the GameCube was a very pure and simple console built with durable components and peripherals; here were controllers that you could toss across a room in a rage and they'd *probably* survive (not that I'd recommend trying that). It was a platform for one medium only – not for watching movies or playing music – and it had a slogan to match: 'Born to Play'.

Sold for a lower price than the PS2 and Xbox, the GameCube achieved sales of over 21 million – not a disaster, but significantly beneath Nintendo's projections of 50 million, and behind both the PS2 and the Xbox. For Nintendo to be third in a console generation was unheard of. Something had to change – and change did come in 2006, with the 100-million-selling Wii.

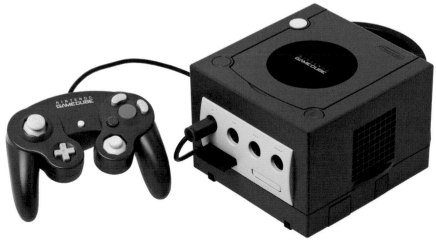

LUIGI'S MANSION

The GameCube, unlike Nintendo's previous home consoles, launched without a *Super Mario* title, *Super Mario Sunshine* only arriving in summer 2002. What it did have was *Luigi's Mansion*, a chance for Mario's brother to shine in his second headline game. (The first, *Mario Is Missing!*, was an educational title for the SNES.)

Luigi's Mansion wasn't a platformer, however, but rather a kid-friendly *Resident Evil* clone in which Luigi explores a haunted house, trapping ghosts as he goes. And much like *Mario Is Missing!*, the real objective was to rescue Nintendo's most famous character.

In the end, *Luigi's Mansion* sold 3.6 million copies – not a bad effort at all from the brother who was (and remains) so often in the shadow of Nintendo's

mascot. It received a 3DS sequel in 2013, *Luigi's Mansion: Dark Moon*, with Nintendo announcing a third game in the series, for the Switch, in September 2018.

SUPER SMASH BROS. MELEE

The GameCube's biggest seller, with over 7 million copies sold, remains 2001's *Super Smash Bros. Melee*. For *Smash Bros.* pro players, this is the definitive entry in Nintendo's crossover fighting series.

Melee expanded on its N64 predecessor's roster, adding Doctor Mario, Bowser, Princess Peach and more. Additional play modes gave it greater depth for solo players who couldn't consistently get their friends to huddle around the same TV. Still featured in elite fighting game tournaments today, its impact

was such that Nintendo made all three of its subsequent *Smash Bros.* entries – for Wii, Wii U and Switch – compatible (via an adapter) with the GameCube controller.

METROID PRIME

The first home console *Metroid* game since 1994's *Super Metroid*, 2002's *Prime* is a fantastic first-person puzzle-shooter and the kickoff of an all-new trilogy in the ongoing adventures of Samus Aran. The debut game from Retro Studios, a Nintendo subsidiary based in Austin, Texas, it is set between the events of the original *Metroid* of 1986 and its sequel, 1991's *Return of Samus*.

It finds Samus investigating the ancient Chozo race on the planet Tallon IV – but her longtime enemies, the Space Pirates, are also on the scene. Earning a swathe of 9s and 10s on release, *Prime* matched the critical acclaim of *Super Metroid* and won several 'game of the year' awards.

The *Prime* trilogy wrapped with 2007's *Metroid Prime 3: Corruption* for the

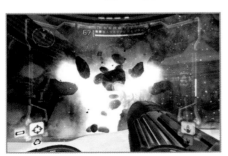

Wii, but a fourth *Prime* game is in development for the Switch, with Retro on board again.

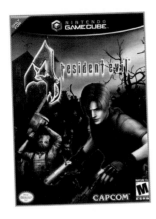

RESIDENT EVIL 4

Initially a 2005 GameCube exclusive before releasing for PlayStation 2 the same year, Capcom's *Resident Evil 4* – actually the sixth major *Resident Evil* game – took the survival horror series in a more action-orientated direction.

Following Leon S. Kennedy, a playable character in *Resident Evil 2*, as he investigates cult activity in rural Spain in search of the US president's missing daughter, it introduced the now common over-the-shoulder shooting style seen in the *Gears of War* and *Uncharted* series. One of the most revered video games ever made, *Resident Evil 4* took home a host of annual awards in 2005. IGN readers voted it the greatest game of all time in 2008.

THE LEGEND OF ZELDA: THE WIND WAKER

The first of three *Zelda* games released for GameCube (and later rereleased in HD on the Wii U), 2002's *The Wind Waker*'s dramatic aesthetic direction – it used *Jet Set Radio*-like cel shading to give it a cartoony quality – initially divided fans of the series. But once

the adventure was underway, it was clear to anyone playing that this was another incredible entry in Nintendo's long-running role-playing franchise. Set largely at sea, with Link using a talking boat, the King of Red Lions, to travel between islands, *The Wind Waker* is also notable for not starring Princess Zelda herself. The pirate captain Tetra is an incarnation of her, however, and it's her that Link ultimately rescues from regular antagonist Ganon. It was with *The Wind Waker* that the 'Toon Link' variant of its protagonist was born, a character that featured in both *Phantom Hourglass* and *Spirit Tracks* on the Nintendo DS, and has also been a mainstay of the *Smash Bros.* series since its *Brawl* outing for the Wii (2008).

MICROSOFT XBOX

With Atari having faded after the failure of the Jaguar, US-made consoles had disappeared by the end of the 1990s. Microsoft's Xbox changed that, launching with great fanfare in 2001, promising hardware on a level with high-end PCs and an online service – Xbox Live – to beat all others. Americans ate it up – over 1.5 million units were sold in that market in the first three months, and by 2006 it'd climbed to 16 million in sales. The rest of the world was less accepting of this newcomer, however. In Asia, home to Sony, SEGA and Nintendo, the Xbox would sell only 2 million units, and the Xbox brand has never found lasting success in Japan.

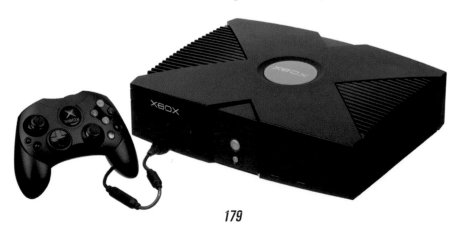

High-tech on the inside but fairly garish to look at, the Xbox was supported by some shrewd business moves by Microsoft. The company acquired developer Bungie, which produced *Halo: Combat Evolved* as a launch title, and Rare, which had previously made several hits for Nintendo and came through with a well-received *Conker* sequel, *Live & Reloaded*. But if the original Xbox is memorable for anything – apart from its massive 'Duke' control pad (recognized by *Guinness World Records* in 2008 as gaming's biggest pad) – it's the emergence of John-177, AKA Master Chief.

HALO: COMBAT EVOLVED

GoldenEye 007 aside, the most successful FPS games of the 1990s – *DOOM*, *Half-Life* and *Quake* – were on PC, where mice gave players pinpoint accuracy. But *Halo*'s twin-stick controls – movement left, camera right – made an instant impression with gamers, and they became the standard for console games of the genre. (Not to say that *Halo* was the first game to use this setup – step forward, 2000's PlayStation-only *Alien Resurrection* – but it was its most popular early adopter.)

Halo was more than a showcase for controller ingenuity, though. Its story, with protagonist Master Chief John-117 at the centre of an epic sci-fi tale of intergalactic warfare and the ancient megastructures which give the game (and series) its name, was a virtual rollercoaster of action and emotion. Sharp gunplay and vehicle sections won plaudits, as did a stirring soundtrack. *Edge* called it 'the most important launch title ever', and GameSpot.com declared it 'one of the best shooters on any platform'.

Master Chief, a biochemically enhanced future solider never seen without his helmet on, became the leading man of the *Halo* series, playable in four further games and present in most related media, and emerged

as Xbox's unofficial mascot. The *Halo* franchise expanded into books, comics and more, including a TV series for Paramount+ that debuted in 2022. The games have continued too, with developer 343 Industries' *Halo Infinite* of late 2021 serving as a spiritual reboot for the series and its supporting lore.

STAR WARS: KNIGHTS OF THE OLD REPUBLIC

Perhaps the best *Star Wars* game ever, *Knights of the Old Republic* was developed by Canada's BioWare (*Mass Effect*, *Baldur's Gate*) and released in 2003 on Xbox before anything else. An action-orientated role-playing adventure, it's set 4,000 years before the rise of the Galactic Empire – the main bad guys of the original *Star Wars*

trilogy – which meant that its makers could have a lot of fun with its cast of characters without worrying too much about established canon events.

Nevertheless, this is a story of Light versus Dark, Jedi versus Sith – the binary conflicts that defined *Star Wars* – and players could reflect their 'side' by choosing their lightsaber's colour. Not that selecting red actually made you a baddie, or purple automatically made you as cool as Mace Windu; players could even opt for a double-ended weapon akin to the one made famous by Darth Maul in *The Phantom Menace*.

Knights of the Old Republic won over forty 'game of the year' notices, and in 2010 ranked third on IGN's 'games of the decade' list, behind only *Shadow of the Colossus* and *Half-Life 2*. A remake of *KOTOR* was announced in 2021, developed for PC and PlayStation 5.

FABLE

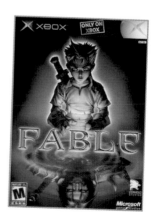

Fable's development began for the Dreamcast, but the early exit of SEGA's console saw developer Big Blue Box Studios, with support from its parent company Lionhead (which would later become a Microsoft subsidiary), switch focus to the Xbox. It was pitched as an RPG unlike anything that'd come before, with a protagonist who'd age and whose decisions would directly impact the world and other people around them. Leave someone alive, or have them executed? This is the kind of high-stakes decision you'll make in a *Fable* playthrough.

Set in the world of Albion, *Fable* was a story full of fun, mystical mumbo jumbo centred around a magical sword that could only be wielded by someone of a specific ancient bloodline. And, wouldn't you just know it, one of those rare people is you, the game's hero. In a neat twist, the player's actions – for good or for evil – would be reflected in the character's appearance, with an evil alignment bestowing inhuman features. Consumption also alters your on-screen avatar: excessive food makes them fat, and overdoing the beer makes them sick.

Fable once carried the working titles 'Wishworld' and 'Project Ego', and its ambitions were given a big sell – Lionhead co-founder Peter Molyneux proclaimed that it'd be the best game ever. On release, *Fable* wasn't quite the revelation its hype implied, and was missing a few promised features; but its sequel, *Fable II* (2008), harnessed the increased power of the Xbox 360 to successfully deliver the supreme vision hinted at by its predecessor.

13 RETRO GAMING TODAY

While there are thousands of video games of the past that you cannot play today, most of the games featured in this book are still available, one way or another.

There is an ever-growing number of official compilations, in physical and digital stores, collecting a certain publisher's 'greatest hits', or games of a particular genre, or era.

Capcom and Konami, for example, have in recent years pulled together hit games from their significant catalogues. A host of Atari's 2600-era games are available to download via the digital storefronts of a few consoles. SEGA regularly packages its 16-bit best in compilation releases, issued both digitally and physically, and the company has even reissued some of its Saturn and Dreamcast games. Nintendo has a history of making popular games from its NES, SNES and Game Boy libraries available digitally, via its eShop service and Switch Online subscription.

Platform-specific mini-consoles have proven popular with gamers, new and old alike. These shrunken-down versions of original systems come preloaded with a host of titles – Nintendo's NES and SNES Classics include games from the *Mario Bros.*, *Metroid*, *Zelda* and *Punch-Out!!* franchises.

SEGA got in on the mini-console action in 2019 with the Mega Drive Mini, packed with forty games. Similar plug-in-and-play versions of the Commodore 64 and Amiga, PC Engine, ZX Spectrum and original PlayStation – each officially licensed and above board – have been released. So too have desktop-sized versions of classic arcade hardware, packed with games, from SEGA (the Astro City Mini), Neo Geo (the Neo Geo Mini) and Taito (the Egret II Mini).

Remakes and remasters are another way in which greats of the past live on, with series like *Crash Bandicoot*, *Resident Evil* and *Spyro* all benefitting from incredible updates. Not every comeback is a success – a remake of *Flashback* in 2013 went down like a lead balloon; likewise, a 2018 3D version of *Secret of Mana* was a bust. But when evergreen gameplay and stories meet contemporary polish and mechanics, the results are usually pretty awesome.

The classics simply refuse to go out of style, and we can still play (much of) the very best of them. And while, unfortunately, there will always be casualties, the games that fall by the wayside with each generation, we have good reason to hope that tomorrow's passionate players will just as easily experience *Space Invaders*, *Super Mario Bros.* or *Metal Gear Solid* as those of us who enjoyed and loved them the first (or second, or third) time around.

ACKNOWLEDGEMENTS

Thanks to Louise, Elliott, Toby, Arthur, Abigail, everyone at Michael O'Mara, these dusty stacks of old video game magazines, and to SEGA and Nintendo for turning playgrounds into battlegrounds back in school.

Unless otherwise indicated, all box art and screenshots in this book are used with permission of MobyGames (mobygames.com). MobyGames is the oldest, largest and most accurate video game database on the internet, founded in 1999 and covering over 260 platforms from 1950 to the present day.

The illustrations on pp 7, 33 (bottom) and 185 are from shutterstock.com.

Images used under a Creative Commons licence and attributed to their original authors are as follows: Amos, Evan: pp 17 (bottom), 18 (all), 19 (top), 38 (top), 39 (middle), 63 (middle), 64, 82, 95, 119 (all), 123 (middle), 153, 154 (bottom), 165; Bertram, Bill: pp 20, 27 (second from top, also attributed to Liftarn, and bottom), 104 (bottom), 105; Bilby: p 27 (third from top); fiskfisk: p 124; Kaiiv: p 104 (top); Livingston, Barney: p 27 (top); Muband: p 45; PViana, The: p 55; Quach, David: p 80 (middle); Sega Retro: p 53 (bottom).

All other images public domain.

INDEX